American Cultural History: A Very Short Introduction

VERY SHORT INTRODUCTIONS are for anyone wanting a stimulating and accessible way into a new subject. They are written by experts, and have been translated into more than 45 different languages.

The series began in 1995, and now covers a wide variety of topics in every discipline. The VSI library currently contains over 550 volumes—a Very Short Introduction to everything from Psychology and Philosophy of Science to American History and Relativity—and continues to grow in every subject area.

Very Short Introductions available now:

ABOLITIONISM Richard S. Newman
ACCOUNTING Christopher Nobes
ADOLESCENCE Peter K. Smith
ADVERTISING Winston Fletcher
AFRICAN AMERICAN RELIGION
 Eddie S. Glaude Jr
AFRICAN HISTORY John Parker and
 Richard Rathbone
AFRICAN RELIGIONS
 Jacob K. Olupona
AGEING Nancy A. Pachana
AGNOSTICISM Robin Le Poidevin
AGRICULTURE Paul Brassley and
 Richard Soffe
ALEXANDER THE GREAT
 Hugh Bowden
ALGEBRA Peter M. Higgins
AMERICAN CULTURAL HISTORY
 Eric Avila
AMERICAN HISTORY Paul S. Boyer
AMERICAN IMMIGRATION
 David A. Gerber
AMERICAN LEGAL HISTORY
 G. Edward White
AMERICAN POLITICAL
 HISTORY Donald Critchlow
AMERICAN POLITICAL PARTIES
 AND ELECTIONS L. Sandy Maisel
AMERICAN POLITICS
 Richard M. Valelly
THE AMERICAN PRESIDENCY
 Charles O. Jones
THE AMERICAN REVOLUTION
 Robert J. Allison

AMERICAN SLAVERY
 Heather Andrea Williams
THE AMERICAN WEST Stephen Aron
AMERICAN WOMEN'S HISTORY
 Susan Ware
ANAESTHESIA Aidan O'Donnell
ANALYTIC PHILOSOPHY
 Michael Beaney
ANARCHISM Colin Ward
ANCIENT ASSYRIA Karen Radner
ANCIENT EGYPT Ian Shaw
ANCIENT EGYPTIAN ART AND
 ARCHITECTURE Christina Riggs
ANCIENT GREECE Paul Cartledge
THE ANCIENT NEAR EAST
 Amanda H. Podany
ANCIENT PHILOSOPHY Julia Annas
ANCIENT WARFARE
 Harry Sidebottom
ANGELS David Albert Jones
ANGLICANISM Mark Chapman
THE ANGLO-SAXON AGE John Blair
ANIMAL BEHAVIOUR
 Tristram D. Wyatt
THE ANIMAL KINGDOM
 Peter Holland
ANIMAL RIGHTS David DeGrazia
THE ANTARCTIC Klaus Dodds
ANTHROPOCENE Erle C. Ellis
ANTISEMITISM Steven Beller
ANXIETY Daniel Freeman and
 Jason Freeman
APPLIED MATHEMATICS
 Alain Goriely

Eric Avila

AMERICAN CULTURAL HISTORY

A Very Short Introduction

OXFORD
UNIVERSITY PRESS

OXFORD
UNIVERSITY PRESS

Oxford University Press is a department of the University of Oxford.
It furthers the University's objective of excellence in research, scholarship,
and education by publishing worldwide. Oxford is a registered trade mark of
Oxford University Press in the UK and certain other countries.

Published in the United States of America by Oxford University Press
198 Madison Avenue, New York, NY 10016, United States of America.

Library of Congress Cataloging-in-Publication Data

Names: Avila, Eric, 1968- author.
Title: American cultural history : a very short introduction / Eric Avila.
Description: Oxford ; New York : Oxford University Press, [2018] |
Series: Very short introductions | Includes bibliographical
references and index.
Identifiers: LCCN 2018010029 (print) | LCCN 2018021548 (ebook) |
ISBN 9780190200596 (updf) | ISBN 9780190200602 (epub) |
ISBN 9780190200619 (online component) |
ISBN 9780190200589 (pbk. : alk. paper)
Subjects: LCSH: United States—Civilization. | Popular culture—United
States—History. | National characteristics, American—History.
Classification: LCC E169.1 (ebook) | LCC E169.1 .A98 2018 (print) |
DDC 973—dc23
LC record available at https://lccn.loc.gov/2018010029

Printed and bound by
CPI Group (UK) Ltd, Croydon, CR0 4YY

For Tai, a little book for a little guy

Contents

List of illustrations

Acknowledgments

I am indebted to the scholars whom I think of as the first
generation of American cultural historians, whose research and
writings brought me into this field of study. I was introduced to
their work in the late 1980s when I was an undergraduate student
at Berkeley, where I was inspired by the lectures and books of
Lawrence Levine, whose work continues to shape the field. I also
must cite the research of Larry May and Elaine Tyler May, Kathy
Peiss, Gunther Barth, John Kasson, Roy Rosenzweig, Robin D.G.
Kelley, Steven Ross, John Demos, Robert Rydell, Peter Novick,
Ramón Gutiérrez, Mary Ryan, David Nasaw, David Roediger,
Lynn Spigel, Alice Echols, Karen Halttunnen, George Lipsitz,
Michael Denning, and others, whose work stoked my historical
imagination. Thanks also to the next generation of scholars in the
field, including James Cook, Phoebe Kropp, David Henkin, Tricia
Rose, and Philip Deloria. The work of these scholars, and others,
shapes the approach and content of this book. It represents the
best reminder of why culture matters and how its history
illuminates the lived experiences not of the rich and powerful,
whose voices ring out loudly throughout American history, but of
ordinary Americans, those whose voices have been too often
silenced, ignored, and forgotten.

I also owe much gratitude to hundreds of undergraduate students
and a handful of graduate students at UCLA, where I have taught

American cultural history for the past twenty years. Their questions, insights, and ideas continue to challenge my cherished assumptions about the subject, and I am grateful to have learned from them *almost* as much as they have learned from me. I especially want to thank my colleagues Stephen Aron, Carla Pestana, and Ron Mellor for their comments and suggestions on early drafts of the manuscript, as well as several graduate students who were kind enough to share feedback, including Peter Chesney, Amanda Martinez, and Bernard James Remollino. Much gratitude also to Nancy Toff at Oxford University Press for keen editorial insights and great anecdotes and to Elizabeth Vaziri and Lakshmanan Sethuraman for help with manuscript preparation.

Introduction: The stories of American history and why they matter

In 1852, Harriet Beecher Stowe wrote *Uncle Tom's Cabin*, a novel first published in serial form in an abolitionist newspaper, *The National Era*. Although it adopted the sentimental themes of contemporary literature, the novel also took a searing look at the horrors of slavery, condemning the institution as cruel and immoral. It sold half a million copies in the United States and more than a million in England by 1857, and it was translated into many languages and adapted for the stage. Yet it also spurred a sharp backlash from slavery's stakeholders, many of whom wrote their own novels and plays to dramatize how southern slaves were better off than wage laborers in the North. In all its iterations, in print and on stage, *Uncle Tom's Cabin* became a lightning rod in the polarizing debate over slavery, sparking enough controversy for Abraham Lincoln to allegedly remark when he met Stowe for the first time that she was "the little woman who wrote the book that made this great war."

The president's observation that a work of fiction could "make" the American Civil War, the bloodiest, most divisive conflict in American history, opens this very short introduction to American cultural history, which emphasizes culture as a driving force in history. If economic history is the history of wealth and its distribution; if political history is the history of governments and state formation; if military history is the history of armies and

war; if environmental history is the history of human interactions with nature; cultural history is, quite simply, the history of stories, their origins, transmission, and significance in time. It became a full-fledged subfield of the American historical profession by the 1980s, inheriting scholarly traditions from Germany, Great Britain, and France. It has examined cultural expressions in their historical context, developing an interdisciplinary approach that has borrowed insights and methods from other fields, including anthropology, literature, art and architectural history, media and communication studies, linguistics, and philosophy. By broadening their definition of what constitutes historical evidence—by exploring the transmission of written, spoken, and visual artifacts over time—American cultural historians excavated the lost voices of American history, the values, beliefs, and attitudes of people on the margins, whose cultural expressions had been salvaged from obscurity.

"Culture," the British scholar Raymond Williams pointed out, is an ornery word, one of the most difficult to define in the English language. Etymologically, "culture" relates to words such as "cultivate," with biological connotations—a living organism, like the cultures developed in laboratories for scientific research. Beginning in Europe in the nineteenth century, the word became associated with ideas of "civilization," particularly in societies increasingly self-conscious about their growing wealth and power. Thus the British poet and social critic Matthew Arnold defined culture in the mid-nineteenth century as "the best which has been thought and said," introducing the idea of culture with a capital "C" to connote the elevated, rarified realm of educated elites who have appropriated opera, Shakespeare, and orchestral music as "high culture," as opposed to "low" or "lowbrow" culture, that which consumed the lives of ordinary people—"the masses" or hoi polloi.

This hierarchical model of culture developed to create a sense of order amidst the chaos of rapid urbanization and industri-alization, but the twentieth century introduced more objective,

universal understandings of culture, particularly through the work of the anthropologist Franz Boas, who described culture as a way of life or "the ways people inhabiting a common geographic area…do things… the ways they think and feel about things." Around the same time, in Germany, social scientists were developing similar ideas of culture as "the totality of ideas in a society, popular, as well as scholarly, low as well as a high culture." Since then, various philosophers, anthropologists, linguists, and sociologists, both in Europe and in America, have qualified the term with notions of "high culture," "folk culture," "mass culture," and "popular culture," the latter two born with the advent of mechanical reproduction in the nineteenth century. We also have references to national cultures or regional cultures as well as more recent uses of the word that refer to various forms of human difference, like gay culture, Jewish culture, black culture, and diasporic and transnational cultures.

Historians of culture rely upon surviving evidence to capture the less tangible, less quantifiable aspects of the human past, the expression of meaning, values, symbols, ideas, knowledge, and ideology, as packaged within cultural texts that are then preserved within archives curated by experts in classified realms of knowledge. The first generation of American cultural historians sifted through this material, looking for clues to the worldview, or mentality, of a people in a particular time and place, be it Puritans in New England, slaves in the antebellum South, or the nouveau riche of suburban Los Angeles. Materials consisted of a wide variety of printed, written, or illustrated texts, including, but not limited to, drawings, maps, letters, poems, diaries, novels, plays, charters, sermons, newspapers, pamphlets, and even sheet music, board games, and playing cards. It also included oral traditions of storytelling passed down across generations as well as a range of expressive practices, like art, architecture, landscape design, fashion, sport, theater, and parades as well as rituals connected to spiritual beliefs such as funerals and weddings. Post–Civil War cultural historians have accessed vast troves of cultural material,

amassed through mechanical or electronic reproduction, and they have found new life in digitization. Americans in the past and present have relied upon photographs, motion pictures, music recordings, television programs and their digital versions broadcast through satellite signals streamed by computers and their handheld versions, and other forms of communication to express themselves and transmit the values, beliefs, and ideas that constitute culture.

These disparate materials are the stuff of cultural history, the "texts" through which culture is created and transmitted. The stories embedded within these texts are usually fictional, but not always. Maps and newspapers, for example, tell stories, even though they purport to present factual representations of the world, either through the science of cartography or through journalistic standards of truth and objectivity. Yet the human propensity for bias, often unconscious, shapes newspaper content, either through editorial decisions to cover certain stories and not others or through a reporter's choice of words that carry implicit values and assumptions. Like newspapers, maps can lie and distort. Cartography, as it took shape during the period that marked the thrust of European expansion, often diminished the size of other continents relative to Europe, or it demarcated imagined boundaries between rival nations and empires.

Cultural historians do not presume easy distinctions between fact and fiction; they see the potential for human bias in all cultural texts (including their own scholarship), and they consider the ways in which such bias subverts or supports the status quo. While they rely upon factual (archival) evidence to support their claims, they are less interested in facts and more focused on their interpretation by diverse social groups. It is a fact of American history, for example, that 14 to 15 million Africans and their descendants were enslaved between 1609 and 1865, but the radically different interpretations of that fact, as embodied within a wide variety of cultural texts, from Sojourner Truth's *Ain't I a*

Woman? (1851) to Hollywood's rendition of *Gone With the Wind* (1939) to the silhouette cutouts of the twenty-first-century artist Kara Walker, fuel the very debates that animate cultural history.

Culture, like war, is politics by other means. This premise, which Lincoln himself seemed to have acknowledged, underlies this survey, which blurs the boundaries between "culture" and "politics," exploring cultural expressions and their deep roots in political, and at times violent, contestations over power and resources. Today's cultural historians inherit two conflicting intellectual traditions. One tradition views culture as a form of domination. Just as Marx in his time pronounced religion the "opiate of the masses," a twentieth-century generation of his disciples, who took mass media as their object of study, saw movies, magazines, newspapers, radio, and television as a new religion that bolstered corporate monopoly and distracted the toiling masses from the conditions of their own oppression. The other tradition, which came later, after the social upheavals of the 1960s, and fueled the broader acceptance of cultural history within the American historical profession, emphasized culture as a tool of resistance, a means of speaking truth to power and asserting the dignity, agency, and creative autonomy of subordinate peoples. Despite the clash between these "top down" and "bottom up" perspectives, these two intellectual traditions opened new avenues for the fruitful investigation of culture as the site of historic struggles.

This is not to say that all cultural expressions are politically charged with the intent to empower, subvert, or oppress. The elements of fun, pleasure, fantasy, reflection, and escape are an important dimension of cultural experience as well, in the past and in the present. Yet if history, in its broadest sense, is the record of human agency and conflict, if it is made through the intertwined struggles of diverse individuals and interests, then no work of cultural history can disentangle the cultural from the political, economic, and social processes of change. The

distinctions between these processes, fortified within specialized academic disciplines, are thus considerably weakened, if not invalidated altogether. Culture, the British cultural studies scholar Stuart Hall wrote, "is seen to be material because it is the result of social practice and has real effects in shaping and regulating social behavior." Similarly, he argues, "material processes—like the economy or politics—depend on 'meaning' for their effects and have cultural or ideological conditions of existence."

It is the relationship between culture and power that bears emphasis. This requires attention to the market structure of cultural production and the role of capital investment, both public and private, or the abject lack thereof. It means thinking about the choices consumers are given in their cultural diet and the different opportunities afforded to different groups to find positive reflections of their lives. It demands close attention to questions of identity, particularly along the lines of race, class, and gender, whose boundaries are continually shaped and reshaped through expansive cultural traditions, networks, and struggles. Much theoretical work has been done to understand the relationship between culture and identity, or culture as the expression of identity. This work has often focused upon the formation of marginal or subordinate identities—African Americans, workers, and women, for example. In addition, it has turned a recent eye toward the role of culture in the making of dominant identities as well, including "whites," "elites," and "men." The quotation marks underscore the fact that people are not born into these social categories; rather, they are learned from the culture and through engagement with language, where identity is made.

Though historians privilege time in their analysis of cultural expression, it is also useful to consider space, that is, the spatial context of cultural production, and its physical location within distinct geographies. Think of the conquest and settlement of western lands, for example, and the diverse forms of cultural expression engendered by that process, or of the structures built

in the service of cultural experience, such as movie theaters and museums. Admittedly, there is an urban bias in this introduction, which emphasizes the central role of cities as engines of cultural development, with the capital, infrastructure, creativity, and audiences that dictated the historical popularity and influence of particular cultural forms. In the scope of twentieth-century American history, New York and Los Angeles have acted as twin poles, the dual centers of a national culture industry dominated by publishing, film, radio, and television broadcasting corporations. But American culture is more than the output of New York and Los Angeles. It is also the product of diverse regional influences, from the South to Silicon Valley, for example, taking shape in urban, suburban, and rural contexts.

The global context of American cultural production and consumption is a final point to consider. American cultural history itself owes its existence to scholarly traditions from France, Britain, and Germany, just as much of American culture historically reflects European traditions. But since the first accounts of New World contact among Indian, European, and African, American culture has been the sum of diverse global influences, from most every part of the world. This has been a recurring theme in American cultural history, and some examples ahead illustrate how disparate forms of cultural expression have played a critical role in a global balance of power, which up to this point has generally favored the United States. At the same time, American culture has not contained itself within national boundaries. The transnational flow of American capital, enabled by domestic and foreign policy, puts hamburgers, automobiles, Michael Jackson, Mickey Mouse, movies, and iced caffè lattes into global circulation, even as immigrants from abroad bring new cultural practices and traditions that influence the national mainstream. In the age of digitization and the Internet, the pace of cultural exchange has accelerated beyond what was imagined possible just a generation ago. This very short introduction emphasizes the roots of that exchange deep in the nation's past.

Chapter 1
American culture in red, white, and black

"The West" began as an idea, not in the minds of white Americans drifting from the Atlantic to the Pacific, but rather in those of Europeans, who defined themselves as "Western" to distinguish themselves from people inhabiting the dimmer reaches of the Eurasian continent. In that mindset, "the West" encompassed Europe's volatile patchwork of sovereign cultures—the East remained largely unknown, the stuff of fable, myth, and lore, often confused with the Americas, which held a distinct, if misguided, fascination for European explorers. When Christopher Columbus crossed the "Great Sea of Darkness" to reach Hispaniola in 1492, his published accounts of his expedition set off a continental obsession with the "Indies," its exotic peoples, their strange environment, and their even stranger lifeways.

Yet as the Spanish, French, Russian, and English infiltrated the interior of the North American continent, and as they expanded their influence in other parts of the world (along with the Dutch and the Portuguese), Europeans began to think less of their internal differences and more of their similarities. This new self-awareness precipitated an idea of "the West" by which European societies distinguished themselves from non-European civilizations. The Enlightenment, that intellectual movement that posited Europeans—their governments, their cultures, their economies—as the very summit of human achievement, furthered

this new self-awareness, but so did exploration and colonial expansion, which introduced the idea of "the Other," that is, the peoples of Asia, Africa, and the Americas, who became the straw men by which Europeans recognized their societies as industrialized, urbanized, capitalist, secular, and modern. European immigrants to North America of the seventeenth and eighteenth centuries came with this mindset, establishing a new society and a new nation, with its own identity that adopted the cultural contributions of diverse peoples, not only indigenous first inhabitants, but also immigrants from Europe and slaves forcibly removed from Africa.

Through words and images, Europeans developed a new self-awareness, as they saw their internal similarities and external differences as distinct from more distant peoples. Drawing upon a wealth of medieval sources, from classical mythology to religious and biblical texts to travel accounts of early explorers, Europeans developed an early comprehension of the New World and its peoples, part fact, part fantasy. Such "knowledge," in turn, informed popular accounts of contact between Europeans and indigenous peoples, especially during the explorations of the sixteenth and seventeenth centuries. *Historia Americae*, for example, consisted of ten illustrated volumes published by the Flemish engraver Theodor de Bry between 1590 and 1634 that depicted elaborate scenes of the life and customs of New World peoples. For some of this work, de Bry translated the simple, unpretentious sketches that the English artist and explorer John White had produced of the Algonquin peoples of Virginia in 1587, retouching facial features, adjusting gestures, and reworking postures to conform to European aesthetic conventions. Through such adjustments, de Bry created a distinctly Western way of seeing New World peoples, taming and civilizing their image for European mass consumption.

Through the mass circulation of such images within an expanding print culture, Europeans increasingly developed

a unified self-awareness as "Western," always in contrast to the "other," that enabled Europeans to recognize and represent their society as the very summit of progress. African, Indian, and Asian peoples were banished to the conceptual edge of Western thought, yet they stood at the center of debates about civilization, refinement, modernity, and development. Thus, newly formed ideas about the civilized, European self and the savage, non-European "other" framed colonial encounters in North America, and they introduced new stereotypes that structured relations between European settlers and indigenous peoples. With mechanized weapons and mass epidemics to their advantage, Europeans labored to impose their religious traditions upon non-Europeans, even as they ruthlessly extracted from them their labor and land. Their efforts depended upon assumptions about the spiritual depravity of Indians: because they were not Christian, they therefore lacked religion, though, in fact, they maintained powerful traditions of faith and spirituality, sometimes parallel to the monotheistic structure of Christianity. Still, for Spanish colonizers in the Southwest, as for British settlers from Massachusetts to Virginia, Indians were "heathens," living in darkness and ignorance.

What Europeans failed to see, however, was the diversity and complexity of North America's indigenous societies. By 1492, the native peoples of North America spoke around 400 distinct languages, and they had adopted diverse sets of rituals, spiritual beliefs, food ways, mythic stories, and kinship systems—all the things that Western scholars distinguish as "culture," separate from the economic, political, or social aspects. Indigenous people, however, did not acknowledge such distinctions. For them, the spirit world infused the physical world, as well as the cycles of human life, and even the experience and perception of time, which flowed in cycles powered by divine providence, not the straight lines through which Western societies imagine their ideals of progress. Native cultures were organized along both matrilineal and patrilineal lines, and they included same-sex relationships in some instances. They relied upon oral, not

written, traditions of storytelling to preserve cultural memory and pass it on to future generations. Indian peoples also maintained a spiritual relationship to the land and its life-preserving resources, and they developed a rich material culture that suited practical, aesthetic, and spiritual needs.

Ignorant of such complexity and diversity among Indian peoples, Europeans, whether Protestant settlers in New England or Spanish explorers in the Southwest, arrived in North America convinced of their superiority, based upon their traditions of Christianity, gender, and family relations and their economic system of sedentary agriculture. Although Indians were the first occupants and possessors of New World land, their relationship to the land—fluid and communal in nature, without formal properties of title and transfer—enabled Europeans to stake their claim, justifying their acquisition by pointing to the "waste" of land in its natural state, unmarked and untilled by human effort.

In 1697, for example, John Higginson praised how "a wilderness was subdued... towns erected, and Churches settled... in a place where... [there] had been nothing before but *Heathenism, Idolatry,* and *Devil-worship*." His emphasis upon the spread of a shared Protestant culture that included prayer, Bible-reading, and the jeremiad sermon, a rhetorical style of preaching that could galvanize a congregation and promote church membership, thus prescribed productive uses of the land, especially town building. For Spanish, French, and English settlers, preliminary ideas about race provided a convenient language through which to rationalize their takeover of Indian lands (though formal systems of racial thought were not fully developed until the late nineteenth century). That premise made white racial identity a prerequisite for private land ownership, codified through formal law. Whether through ideas of "race," "civilization," "family," or "salvation," Europeans of diverse cultures arrived in the New World armed with beliefs and attitudes that justified their conquest.

Thus, the early conflicts between European colonizers and indigenous peoples in North America were not simply political struggles over sovereignty and jurisdiction or economic competition over resources and wealth; they were also cultural contests between clashing sets of meanings, values, and beliefs. Catholic missionaries in New Spain, like Protestants in the English colonies, targeted indigenous forms of spirituality by physically destroying the objects and spaces that held spiritual meaning for native peoples, imposing substitutes in the form of Christian icons, symbols, and texts. This was a crude form of cultural warfare in early America, leaving Indian peoples at a severe disadvantage. When shamans could no longer protect their people from the onslaught of diseases like smallpox, influenza, and measles, or from assault by mechanized weaponry, for example, they lost the traditional healing powers that sustained their cultural authority within Indian societies. Moreover, as European invaders cleared North American forests and depleted natural resources, they erased the spiritual and cultural meanings that Indian peoples derived from the natural environment. Physical destruction thus entailed a form of cultural death.

Still, Indians made lasting contributions to the development of a national culture. European settlers in America adopted such dietary staples as corn, beans, squash, cranberries, chocolate, and peanuts from native food ways. Canoes, toboggans, kayaks, tobacco, pipe smoking and cigars, and tomahawks reflected the influence of native American technologies. Thousands of American place names, from Sebago, Maine, to Malibu, California, stem from indigenous naming practices (approximately half of American states have Indian names). In a hostile New World environment, moreover, colonial settlers could not have survived without borrowing Indian agricultural practices and knowledge of the land. Even indigenous systems of governance, particularly the Iroquois Federation of Six Nations, inspired the structuring of the U.S. federal government, as Benjamin Franklin himself once acknowledged. In contrast to familiar narratives of

cultural conflict and decline among Indians, Indian peoples profoundly shaped a national way of life.

Cultural exchange between Europeans and native peoples became even more pronounced as rival colonial economies took root in North America. Outnumbered by the native people, French trappers and traders in the interior of North America learned the ways of Indian culture as a matter of survival. French missionaries arrived prepared to live among the Indians, familiarizing themselves with native languages and customs. These Europeans developed an understanding of Indian ways, adopting native traditions of reciprocity and gift-giving that governed exchanges in woodland Indian societies. To bolster the relationship between French woodsmen and Indians, *coureurs de bois* (runners of the woods) married Indian women, helping to bridge cultural differences.

The *coureurs de bois* became the curious prototype for a uniquely American character, a fusion of European and Indian identities that found powerful forms of historical expression. While Anglo-American colonists generally regarded Indians as savage and inferior, they often found their image useful for new forms of self-expression. Skipping ahead to the Revolutionary period, American colonists found that "playing Indian" could help to create an identity of independence as the figure of the Indian provided a powerful symbol through which to express collective aspirations toward national sovereignty. Political cartoons of the time often depicted the colonies as an Indian, often an Indian woman. One cartoon from 1776 depicted a bare-chested Indian woman slugging a lady of the English court, and another rendered the image of a restrained Indian woman, breasts exposed, forced to swallow tea by Lord North and his gang of court bullies, who wear the ruffles, stockings, and wigs that signal they belong to a decadent British aristocracy, the very opposite of American frontiersmen and pioneers. Such images of European decadence and sexualized violence provided a visual template by which

colonists (and their colonizers) recognized their affinities with native Americans. In the mid-Atlantic states, Anglo-American colonists of the Revolutionary generation established Tammany societies to celebrate all things Indian. These fraternal orders, such as the Red Men Secret Order of Philadelphia, formed in tribute to "St. Tammany," the Anglicized name for the Delaware chief Tamanend, christened by members as the "Patron Saint of America." Expressing a simultaneous attachment to Indian land and an opposition to British rule, Tammany members adopted Indian names, enacted supposed Indian customs, and organized Indian-costumed balls and parades.

The Boston Tea Party of 1773 is undoubtedly the most famous example of playing Indian in Anglo-American culture, when the Sons of Liberty disguised themselves as Mohawk Indians and stormed three ships anchored in Boston harbor to express their opposition to imperial taxation policy. Shouting war whoops as they seized the cargo of the *Dartmouth* and two other British vessels, the "Indians" dumped British tea into the harbor for three hours and then washed off their war paint. The Boston Tea Party was a catalytic moment in the formation of a revolutionary consciousness among British colonists in New England. Yet the element of disguise was critical, a sign that colonial Americans liked their Indians both ways: as an incorrigible savage who blocked the path of westward expansion and as a powerful symbol of freedom with homegrown roots in the New World.

Cultural historians have explored race in colonial America in other ways as well. How Africans became African Americans, for example, has long preoccupied historians of the black experience in the United States. In contrast to pervasive assumptions that slavery deprived Africans and their descendants of a cultural life, these historians found patterns of cultural exchange between Africa and the Americas, especially the American South. African traditions of rice cultivation, for example, flourished in the colonies, bringing a new staple to the American diet. Oral

THE DESTRUCTION OF TEA AT BOSTON HARBOR.

1. The Boston Tea Party in 1773, a catalytic moment in the events leading toward revolution, signaled the power of disguise in the making of a new revolutionary identity and the symbolic affinity of the colonists with native peoples.

traditions of storytelling, similarly, incorporated African songs, jokes, sayings, and fables into the mainstream of southern lore. The fact that colonial slaves and their descendants lived in isolation from whites in slave quarters or in other segregated communities enabled the survival of West African cultural forms of speech, fashion, naming practices, diet, festivals, celebrations, and funeral rites. New patterns of speech and language also emerged, beyond earshot of white masters, as black slaves blended native African dialects with learned English, creating a new patois, often unintelligible to whites. Creole languages such as Gullah, spoken in South Carolina and Georgia, also helped to preserve the diverse spiritual traditions, including Islam, which was practiced in certain areas of West Africa.

African American burial practices in the colonies illustrate the synthesis of African and Anglo-American spiritual traditions. In 1991, city officials in New York discovered a burial site in lower

Manhattan, six acres in which both free and enslaved blacks were buried roughly between the 1690s and 1794. Archaeological investigations showed that while blacks were usually buried in ways identical to whites, some burials revealed material links to African funeral traditions. This included the placement of goods in coffins to be used by the deceased in the afterlife—a uniquely African cultural practice. In the African Burial Ground in New York some coffins included copper rings or glass beads and cowrie shells, originating from the eastern coast of Africa. A woman's body was buried with both a clay pipe of British or American manufacture and waist beads around her hips, characteristic of women's dress in West Africa. Another coffin also included a small cloth bag containing objects of magical or ritual significance, called *minkisi* in Kongolese but used elsewhere in Africa. The remains of another man, probably buried after 1776, were found with fourteen tiny copper-alloy rings between his right arm and his chest. The exhumed bodies of the African Burial Ground revealed material connections with African culture and cosmology, while illustrating a synthesis of European, American, and African traditions to produce a new and distinctive African American culture.

Enslaved Africans in various colonial settings adopted Christianity only slowly before 1800. When allowed, they observed traditional African religious customs, such as burial rites and, sometimes, marriage celebrations. Moreover, only a few white members of the clergy actively sought to Christianize the slaves, and slave owners feared it, especially in the South, with its ever-increasing slave population: baptism might imply equality with white Christians and produce "uppity" slaves. When black Americans eventually embraced Christianity, toward the end of the eighteenth century, they adapted the faith to their own aspirations for freedom. The Christian church provided an institutional base of political, economic, and social support for the earliest generation of black Christian Americans. Bethel Church, founded by the former slave Richard Allen in Philadelphia in 1794, promoted the spiritual and

material improvement of black lives and provided shelter from the brutalities of white racism. Similarly, Phillis Wheatley, the slave of a progressive New England family who mastered Greek and Latin and the art of poetry, articulated an impassioned Christian faith that inspired many Americans of the Revolutionary period, white and black alike.

Phillis Wheatley is recognized as an exceptionally gifted figure in colonial America, as a black slave but also as a woman. Colonial America was a patriarchy, a society in which men held power and women were largely excluded from it, based upon male assumptions about the purpose and abilities of women. Its political economy prohibited women from owning or inheriting property, holding public office, and serving in the ministry. Women who defied these strictures were either banished, like Anne Hutchinson, who fled the Massachusetts Bay Colony in 1638 for claiming the right to preach Christian doctrine before a large audience, or hung, like the executed victims of witch trials in late-seventeenth-century New England, most of whom were women. Through speech, property, and wealth, women could transgress acceptable norms of behavior, yet in the course of everyday life, they were expected to remain silent and obedient in the presence of husbands and fathers.

In this context, the first institutions of higher learning were established in the colonies, exclusively for men, as in the European traditions found in the Old World. The earliest universities, what we now call the "Ivy League," extended the institutional forms of European patriarchy to colonial America, as they were established to train ministers and educate the sons of gentlemen. Harvard was the first American college, founded in 1636. Its curriculum included subjects that were traditional at English universities: Latin and Greek, mathematics, some sciences, and philosophy. Together with the founding of the College of William and Mary, chartered in Virginia in 1693, and Yale College of Connecticut, established in 1703, these institutions provided early blueprints

for American higher education, with a bent toward Judeo-Christian intellectual traditions and a classical liberal arts curriculum. These colleges and others also became new centers of scientific thought and discovery, conduits for the scientific revolution unleashed by advances in physics, geography, and astronomy. Thus, institutions like King's College of New York (later Columbia University) tailored their message to emphasize a scientific education, advertising its curriculum in "the Arts of Numbering and Measuring, of Surveying and Navigation, of Geography and History, of Husbandry, Commerce and Government."

The establishment of a formal system of higher education corresponded to rising rates of literacy among whites, distributed unevenly across the colonies. In New England, men had literacy rates of 60 percent between 1650 and 1670, a figure that rose to 85 percent between 1758 and 1762, and to 90 percent between 1787 and 1795. By then in cities such as Boston the rate approached nearly 100 percent. Literacy was higher in New England and the mid-Atlantic colonies than in the South, and it was higher in the cities than in the countryside. The rates of female literacy across colonial America equaled half that of males in general. Blacks were altogether excluded from efforts to extend literacy in the colonial United States, as most slave owners saw inherent dangers in a literate slave population. There were exceptions, however, like Samuel Davies, a Virginia minister who worked to educate slaves in the mid-eighteenth century, convinced that literacy was essential to Christian devotion. Slaves and former slaves themselves recognized the early links between literacy and freedom. In his autobiography, *The Interesting Narrative of the Life of Olaudah Equiano* (1789), the American slave turned English abolitionist Olaudah Equiano described the horrors of slavery and his efforts to teach himself to read and write, producing powerful testimony that fueled growing calls for the abolition of slavery.

Two factors help to explain the high rates of literacy in colonial America. First, the pervasive Protestant culture of the colonies,

despite their semi-separate religious enclaves, included a strong emphasis upon the word: literacy strengthened the individual's direct relationship to the word of God, as found in the Bible, the single most widely read text throughout the history of colonial America and the bestselling book of all time in American history. Until the American Revolution, Protestant Americans in the colonies bought a wide assortment of Bibles imported from England, as imperial copyright laws prohibited their manufacture in the colonies. The centrality of this text in the religious culture of colonial America thus demanded high rates of literacy in order for men and women to acquire a rigorous understanding of the tenets of Christian faith and to join the godly community of saints.

Second, literacy rates were the product and producer of a growing print culture in colonial America that enveloped readers in urban, rural, and small-town settings. Until the political controversies of the 1760s, the most widely read printed works, besides the Bible, were sermons. Annual almanacs were also popular. These were pocket-sized, paper-bound texts, serving as calendars, astrological guides, recipe books, and children's schoolbooks. They also included jokes, poems, and sayings, sandwiched between useful bits of practical information. The better almanacs included the latest scientific findings and presented selections from noted British authors. Benjamin Franklin's *Poor Richard's Almanac* (1732) is the best-known example, selling ten thousand copies a year at the height of its popularity.

The colonial culture of print also introduced the newspaper. The *Boston News-Letter*, founded in 1704, is commonly considered the first newspaper in the colonies. New York, Philadelphia, Newport, Charleston, and Williamsburg also established their own newspapers geared toward merchant readers who needed information about commodity prices, distant wars, ship arrivals, and the latest developments in Europe. Early newspapers appeared once a week, and they usually ran three to four pages long, half of which were devoted to advertisements in very small

print. Often they were read aloud in taverns or alehouses, which became important sites for the exchange of information among rich and poor alike, an informal venue for free political expression, beyond earshot of church and state authorities.

Newspapers supplied literate colonial Americans with a vital network of communication. Their circulation was small by contemporary standards, but readership expanded as the colonies grew more populous, and, in time, they included more space for local news and more overt expressions of political critique, especially of imperial rule. This prompted colonial governors to increasingly monitor and restrict political expression as the colonies teetered toward revolution. Benjamin Franklin's brother, an independent newspaper publisher in Boston, was imprisoned in the 1720s for operating without a license and failing to clear content with Massachusetts authorities. In New York, John Peter Zenger, a German Palatine immigrant, pushed the boundaries of free speech by publishing the *New York Weekly Journal*, the first political party newspaper in the colonies that ran trenchant critiques of the New York governor. In 1734, Zenger was fined and imprisoned for seditious libel, but his acquittal signaled a victory for free expression and authorized newspapers to criticize government.

These men represented a rebellious class of colonial printers who wielded a new form of political power through their influence over public opinion. The Stamp Act of 1765, which leveled a tax upon the distribution of printed materials like newspapers, provoked further resentment within the colonies, which by the 1770s had roughly forty newspapers in circulation. In most cases, their publishers supported colonial resistance to imperial taxation and drew attention to the impending drama of war, independence, and nation-building. They inflamed revolutionary sentiment not only through newspapers, but also through pamphlets, essays, sermons, declarations, and even almanacs. New figures emerged through the printed word, like Samuel Adams, who penned his

arguments for revolution under different pseudonyms to dilute his opinions within an anonymous colonial readership. Similarly, Thomas Paine used provocative language to lambast the British monarchy and promote independence in *Common Sense* (1776), the best-selling pamphlet in the history of colonial America. Officers of the Continental Army read passages from this rebellious tract to their troops, marshaling inspiration from its scathing ridicule of the British monarchy.

The print culture of colonial America also included the Declaration of Independence and the United States Constitution, foundational documents that established the formal basis for a new independent republic. These texts circulated throughout the colonies with increasing speed thanks not only to innovations in printing technologies, but also to the development of a rudimentary postal network. The scientist, inventor, and statesman Benjamin Franklin, widely regarded as the "Enlightened American," foresaw the need for a postal service and served as first postmaster of the colonies, reducing mail rates for printed texts, especially newspapers. After the Revolution, the Post Office Act of 1792 placed Congress in charge of selecting postal routes, protecting the privacy of mail, and setting postage rates. These innovations created broader access to political news in the early republic, spreading a republican ideology that emphasized the virtues of democracy and the imperative of free speech. They also initiated the development of a national communication network that merged readers from urban and rural settings into a singular audience.

Whereas the foundational texts of nation-building spoke only of men and rendered women invisible, women had some access to a literary culture by the late eighteenth century. Novels provided a cultural space for women to emerge not only as authors and readers, but also as characters and symbols of the new nation. While British authors dominated the literary marketplace of the former colonies, two popular and important novels of the late

eighteenth century marked the beginnings of a homegrown literary culture. William Hill Brown's *The Power of Sympathy* (1789), dedicated to "the young women of United Columbia," describes a young woman's effort to avoid "the fatal consequences of seduction." Susanna Rowson's *Charlotte Temple* (1791) also explores the motif of seduction through the trials of its eponymous hero, a fifteen-year-old American girl forced into morally compromising situations by duplicitous European suitors. What these novels had in common was not just their immense popularity in the early republic, but also their sentimental focus upon the seduction of young women, offering a literary metaphor for the fate of the young republic itself and its ability to withstand corruption.

Corruption came in many forms to the Revolutionary generation of Americans, who sought to purge the cultural threats to republican virtue. In 1774, the Continental Congress in Philadelphia proscribed horse racing, cockfighting, card playing, rolling dice, attending the theater, and indulging in expensive entertainments, as these recreations were associated with the much-hated gentry, or "codfish aristocracy," that flaunted its Anglophilic ways. The prohibition of such activities would distinguish the moral superiority of revolutionary colonists in contrast to British decadence, or so the thinking went, but the new flood of affordable luxury goods imported from Britain after 1750 confounded such reasoning. A consumer revolution brought porcelain, fine textiles, handcrafted furniture and art, lace and silver, and other items within reach of wider segments of the colonial population. Local governments responded in kind, trying to restrict the consumption of luxury goods that were associated with aristocratic corruption. American revolutionaries also targeted elite theater venues during the mid-eighteenth century. In 1766, for example, the Sons of Liberty, who later staged the Boston Tea Party, ransacked the Chapel Street Theater in New York City during a performance and set the building aflame. Such patriotic attacks upon the theater as an elite and exclusive

institution foreshadowed subsequent "theater riots" in the coming century, illustrating the theater as a stage for broader social conflicts.

Diverse Americans planted the seeds of a new national culture during the colonial period, one that took shape through the contributions of people from Europe, Africa, and the Americas. Even as rival colonial powers usurped Indian land, and as Anglo-Americans expanded the institution of slavery in the South, a homegrown American culture took shape that reflected a synthesis of European, African, and indigenous influences. Women made distinct contributions to this new culture, even as they found limits to their independence and free expression. The social fissures that divided colonial America deepened in the course of the following century, but in the aftermath of the American Revolution, another kind of revolution took shape that brought radical changes to the structure and experience of daily life. Industrialization had profound consequences for the expanding young nation, not just for its political structure and economic development, but for its cultural life as well.

Chapter 2
Mass culture and mass politics, 1800–1860

In the aftermath of the American Revolution, the framers of the Constitution, or in national lore, the "founding fathers," confronted the task of forging a new national identity. The most concrete manifestation of their endeavor was Washington, DC, a new capital situated by Congress on a parcel of undeveloped land along the Potomac River between Virginia and Maryland. The plan for this new city—a fine-meshed grid with great slashing diagonals that intersected at public squares and circles, studded with gardens and monuments—reflected the founders' ambitions to create a majestic and thriving metropolis, one to rival the capitals of Europe. The scheme that took shape centered on a few key buildings. The Capitol and the White House came first; the original structures were burned down by the British in the War of 1812 and then rebuilt in the 1820s. Both buildings, in their early iterations, reflected the neoclassical style of architecture that flourished in Europe and America during the first half of the nineteenth century. With its disciplined assemblage of columns, porticoes, and pediments, this style evoked the rational symmetry of Greco-Roman design and provided a template for both civic buildings and commercial establishments in towns and cities across the nation. The whiteness of the marble and stone façades on display in the style suggested the cultured image of a Greek temple, creating a symbolic link between the New World republican experiment and the ancient birthplace of democracy.

Yet, while this architectural style evoked the distant past, it appeared during a surging phase of modernization in the United States between the Revolution and the Civil War, fueled by recent technologies of communication and transportation. These developments included the completion of the Erie Canal in 1831, the invention of the telegraph and Morse code in 1837, and the expanding lines of what became a transcontinental railroad network by 1876. As urbanization and industrialization accelerated rapidly, new actors appeared on the scene—a burgeoning working class tied to factory work and wage labor, and a new middle class born of a market revolution and abstract economic forces. These social groupings took shape in a new national network of towns and cities that sprouted, seemingly overnight, along rivers and rail lines, pushing west into a frontier of unsettled lands. In the South, where stately plantations exemplified the neoclassical style, a growing slave system heightened sectional divisions and hardened racial hierarchies. In this stratified society, wracked by insecurity, anonymity, transience, cruel exploitation, and incessant violence, the pediments and columns of neoclassical architecture provided the illusion of a sturdy, civilized, and rational society, but, like many cultural expressions of the time, it also provided a sense of order, fleeting perhaps, but with satisfying answers to troubling questions about identity, status, and national belonging.

Neoclassicism, with its linkages to democracy and liberalism, competed with other architectural styles. The Gothic Revival, a more somber style drawing inspiration from the medieval Gothic period, was adopted as an architectural style by many colleges in the Midwest and Northeast during the 1830s and 1840s. Its features stood in contrast to neoclassicism's rational geometry and looked to the medieval period, not classical antiquity, for aesthetic inspiration. It won favor in the age of romanticism, a European movement in art and literature that reacted against the dry rationalism of Enlightenment philosophy by embracing emotional experience, subjective feeling, and sublime nature. Romanticism

exerted a powerful influence upon American arts and letters during the first half of the nineteenth century, evident in the novels of Edgar Allen Poe, a Baltimore native who explored themes of violence and the macabre in his work, and of Nathaniel Hawthorne, best known for *The Scarlet Letter* (1850), a moral allegory about Puritan witch hunts. The transcendental philosophy of Henry David Thoreau and Ralph Waldo Emerson also bore romantic influences, emphasizing human intuition and the presence of God in man and nature. Thoreau wrote in solitude from his cabin on Walden Pond in Massachusetts, extolling his communion with nature, a theme that informed American art toward the middle of the century. The Hudson River School of artists, a loose collection of landscape painters who strove to depict the divine mysteries of nature, coalesced in the region of the Hudson River valley of New York during the 1830s.

Romanticism also shaped changing attitudes toward mortality. The literary culture of the 1820s included the work of Washington Irving, who wrote odes to picturesque English graveyards, and William Cullen Bryant, who penned such celebrated poems as "Thanatopsis" (1817), or "meditations on death." The elegiac tone of their writing reflected a new liberal belief in the naturalness of death, inspiring innovative rituals and settings for its occasion. In 1831, on the outskirts of Boston, Dr. Jacob Bigelow founded Mount Auburn Cemetery, a new kind of "garden cemetery" that reflected European design influences and provided a new alternative to the foul odors and decrepit condition of cramped urban graveyards. Synthesizing the naturalist styles of English gardens and the French tradition of monumental funerary architecture, Mount Auburn provided a space not only for burial and mourning, but also for commemoration, moral instruction, and the appreciation of nature. With its imposing gate, designed in the Egyptian Revival style, which grew fashionable after British accounts of expeditions into the tombs of the pharaohs during the 1830s, Mount Auburn sprawled across 170 acres of rolling hills, a space adorned with lush plantings, serpentine paths, shady groves,

ponds, and an eclectic assortment of marble statues, obelisks, arches, pyramids, urns, chapels, and sarcophagi. While Mount Auburn and its imitators served the rich and their vision of an afterlife, these places also provided a safety valve for an expanding urban public and a picturesque setting packed with allegorical meanings about nature, death, and everlasting life.

Mount Auburn was built through the efforts of a voluntary association, one of many in cities big and small throughout the nation. While this voluntary association served the elites, most were formed by middle-class reformers aiming to build a better society through the founding of schools, prisons, asylums, and orphanages that would serve to strengthen family life and eradicate social ills. Working in a variety of occupations and earning a range of incomes, the new middle class of the 1820s and 1830s included doctors, lawyers, shopkeepers, small-scale merchants, factory managers, teachers, and others, along with their families. These people worked with their heads rather than their hands, and they were salaried employees, not wage laborers. They did not make things for a living; rather, their income largely depended upon the buying, selling, and managing of other people's production.

The new middle class of the antebellum period struggled to define itself within a new market economy that dissolved traditional markings of status and identity. It did so through a vague ideal of "respectability," a master value that encompassed a host of traits, usually expressed through the signs of dress, behavior, speech, and home furnishings, all meant to convey an ideal of character in an expanding market society. Respectability encompassed ideals of industriousness, sincerity, and authenticity, and it guarded against artifice, hypocrisy, and deception. Echoing the faith of the transcendentalists in human goodness, the new middle class forged a culture of self-improvement, establishing public lecture circuits for self-edification, known as Lyceum societies, and advocating bodily self-control, not just through the temperance

movement, but also through sexual self-discipline, targeting prostitutes and men for their vices of promiscuity and masturbation, the latter a dangerous habit believed to put young men on the road to ruin. Such prescriptions were packaged within etiquette manuals targeted separately toward either sex. *Godey's*

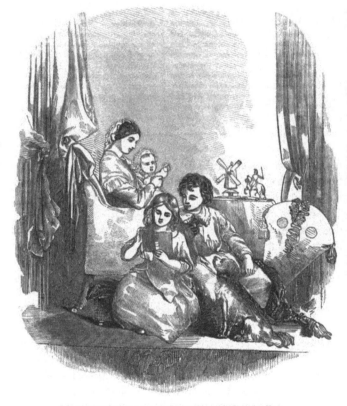

THE SPHERE OF WOMAN.

2. Etiquette manuals positioned women at the center of domestic scenes, as nurturing mothers and guardians of the home. The dog, clothing, furnishings, and toys suggest the material comforts of middle-class domesticity.

Ladies Book, founded in 1830, brought stories, articles, and poems by famous authors together with advice on fashion, architectural plans, and moral instruction. With a circulation of 150,000 by 1860, *Godey's* provided women with a "how to" guide on a variety of domestic affairs.

Etiquette manuals promoted an idealized set of gender roles. A new "cult of domesticity," as historians have labeled it, took shape as a powerful ideology of the middle class during the 1830s, one that circulated through an expanding consumer culture. It designated the middle-class home as a feminine sphere, a place that offered a respite from the masculine world of work and politics, and an incubator of middle-class values. Architecture played a role in this process. New models of domestic space were designed that separated common areas, or parlors, from private bedrooms upstairs. Magazine articles, domestic manuals, advice books, and medical journals promoted these distinctions, upholding the idea that women were naturally suited for child-rearing and household maintenance. Catherine Beecher, a prolific author of advice guides and scion of a prominent family of ministers and writers, called the home a "woman's sphere" and described feminine independence as "contrary to nature." Like other experts of the time, she advocated a portrait of women as loving mothers and doting wives—the weaker sex who remained vulnerable, infantilized, and dependent upon men. While this portrait pervaded antebellum culture, it was challenged by the women who led causes such as temperance and abolition, and it was out of reach for poorer women who worked in factories or as domestic servants.

Though "respectable" middle-class men and women embraced new ideals of domesticity and private life during the antebellum era, urban workers, especially single men, patronized a rowdy world of saloons, concert halls, brothels, and flophouses. The Bowery neighborhood of lower Manhattan, for example, adjacent to nearby shipyards on the East River, offered a carnival atmosphere, a respite from the loneliness of the city and its harsh

work environment. The Bowery Theatre dominated the life of this district, initially built as the New York Theatre in 1826 to serve the city's wealthy merchant class. In 1828, under the leadership of a new manager, Thomas Hamblin, a British-born populist, the theater abandoned its "respectable" fare and began catering to the tastes of working-class roughs, the Bowery "b'hoys" (the Irish and street pronunciation of "boys") who settled in the area and enjoyed "manly" entertainments like prize fighting, dog racing, and heavy drinking. By lowering ticket prices and bringing circus acts, English farce, and American melodrama along with Shakespeare to the stage, Hamblin brought the populist surge of Jacksonian politics to the world of the theater.

Working-class theater of the antebellum era had two primary characteristics. First, its content addressed current events, such as the war with Mexico or the California gold rush. For working-class audiences, the theater provided one of the few ways of experiencing these developments, as representations were performed on stage, packed with humor and political debate. Second, its patrons reflected a diverse cross section of the urban public: not just the "b'hoys" and "g'hals" of the Bowery, but also urban merchants and country traders, Democrats, Whigs, and Republicans alike. Though the classes were partitioned within separate sections of the theater, all spectators shared an active, boisterous participation in the show. To express their disapproval of an actor's performance, antebellum audiences hissed, groaned, or threw fruits and vegetables. When they approved, they would demand that an actor repeat his lines or sometimes an entire scene.

These theater audiences were overwhelmingly white and male (blacks were usually denied admission), although women could attend, but only in the company of male escorts. Prostitutes were usually admitted free of charge, but they were restricted to upper-level galleries. Although it provided an inclusive space for the diverse elements of antebellum society, the theater increasingly reflected the views of an expanding white male

working class, which found its political voice through the extension of universal manhood suffrage and the expansion of a two-party system. By eliminating property qualifications for voting and holding office, the political process ceased to be an upper-class affair, much like the theater, which invited the very kind of boisterous participation that ensued in a new age of mass politics. Newspapers, pamphlets, and books broadcast the messages of the Democratic and Whig Parties to voters, while campaign biographies became a staple of presidential politics, as they are today. Voting became a public act, the culmination of several days of festivities that included demonstrations, banners, performances, and the copious flow of alcohol in both rural and urban settings. Working-class white men stood at the center of this new political culture, activating a durable myth of Jacksonian America as the "age of the common man."

This new egalitarian spirit depended upon the hardening of white racism, an ideology that united white Northerners and white Southerners and found powerful new forms of expression on the theater stage. The Jacksonian era introduced the minstrel show, which debuted on the Bowery stage in 1832, when Thomas Dartmouth Rice arrived from Kentucky with a novel act, painting his face black with burnt cork and spinning about the stage with a curious, jerky motion, singing, "Weel about and turn about, / And do jis so; / Eb'ry time I weel about, I jump Jim Crow." Reportedly, Rice had learned this performance by watching a slave dance at a local market, yet according to one minstrel scholar, Rice witnessed an African American folk dance based on the impersonation, or "delineating" of crows, an African agricultural ritual that survived in the United States. Inspired by this talented slave, Rice elaborated upon his original act, adding other "Negro" performances such as "Me and My Shadow," which included a child in blackface who mimicked his steps.

Largely recognized as the first indigenous form of mass entertainment in the United States, minstrelsy sparked a national

obsession throughout the urban Northeast in the 1830s and reached the height of its popularity in the mid-nineteenth century. Blackface entertainment took many forms and adapted to many kinds of dramatic genres, including Shakespearean theater. Typically, a minstrel show followed a three-act structure. First, a troupe of four or five performers would dance on stage, singing and exchanging wisecracks. The second part usually included stump speeches rife with puns and innuendo. The final act featured a slapstick musical plantation skit or send-up of a popular play (Shakespeare was a favorite target). Minstrel shows usually featured gross caricatures like "coons," "sambos," dandies, and "mammy," who confirmed white stereotypes of blacks as an inferior and degraded race. Minstrel showmen often emphasized the authenticity of their acts by claiming to be a "student of the Negro," or by addressing working-class audiences as "my broder niggars." Yet the very inauthenticity of blackening up—a white man singing, talking, walking "black," usually impersonating men (and often women), is what enthralled white spectators who embraced their racial kin's rendition of blackness. In this racialized spectacle, minstrel performers often told their audiences that they were like widows, because they wore black for only a short while.

In a period of surging immigration from Europe, especially Ireland, an expanding slave system in the South, and a rising abolitionist movement, minstrelsy emerged as a self-consciously white, working-class form of entertainment. It peddled black stereotypes for white profit, confirming white perceptions of blacks as lazy, stupid, violent, and hypersexual. Yet it also demonstrated white admiration, even love, of black culture, especially among workers and immigrants who felt their own enslavement within an exploitative factory system and craved expressive release, if temporarily, from the harsh demands of industrial discipline. Minstrelsy aroused racially conflicted feelings among ethnically diverse audiences who found cause to identify with slaves and their predicament, even as they embraced

32

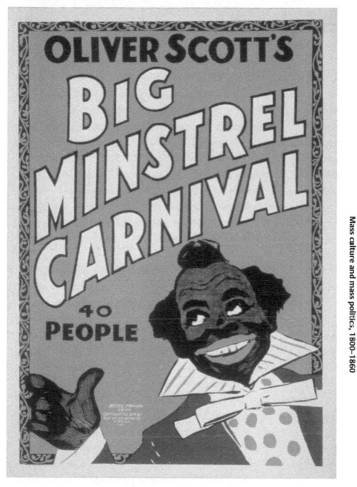

3. Well after its introduction to working-class audiences in the 1830s, the minstrel show went mainstream, broadening its appeal to include those from the middle and wealthier classes in attendance at vaudeville performances and musical revues.

whiteness as a strategy to protest the degradations of "white slavery" in the factory workplace.

While early-nineteenth-century theater drew in a broad cross section of the urban public, it soon reflected new class divisions as well as older nationalist ones. As the new middle class pushed to "clean up" the theater, making it conform to their values of respectability, wealthier members of society began to establish their own exclusive and expensive theaters, much like the "codfish aristocracy" of the colonial period. In 1847, 150 affluent New Yorkers raised money to build the Astor Place Opera House, an exclusive establishment that imposed new standards of decorum and dress codes (such as kid gloves and white vests for men), though it included a "cockloft" for working-class audiences, reached by a narrow stairway and isolated from the gentry below.

The class tensions sparked by the erection of this palatial and exclusive institution were inflamed during an intense rivalry between two Shakespearean actors who appealed to opposing segments of New York theater audiences. In stark contrast stood the patriot and first major American actor, Edwin Forrest, who associated himself with working-class theater, and the British actor William Charles Macready, known for his cerebral style and aristocratic demeanor, who earned the patronage of more affluent audiences. As the two actors traded put-downs in the press, Macready was heckled by Forrest's supporters in his first performance at the Astor Place Theater, fleeing in the middle of the third act under an avalanche of eggs, apple cores, and, in the end, ripped up seats. Though he intended to return to England after this episode, some leading citizens persuaded him to return to the theater on May 10, 1849. Shortly before the performance began, a crowd of thousands amassed outside the theater, shouting "burn the damned den of aristocracy!" They threw rocks at the building and stormed its entrance with 1,800 patrons inside. Militiamen arrived on the scene, firing into the crowd, killing twenty-two and injuring more than fifty others.

The Astor Place Riot of 1849 remains among the most violent episodes of class conflict in American history, another "theater riot" that underscored competing claims to the theater as a shared public space.

Despite the exclusivity of the Astor Place Theater, working-class Americans found reflections of their own lives in other aspects of antebellum popular culture. The "penny press," for example, an outgrowth of colonial-era print culture, cultivated a new community of readers among working-class consumers. Until the antebellum period, newspapers belonged to more affluent segments of society, catering to merchants and lawyers who could afford to subscribe to the sheets that cost six cents. In 1833, Benjamin Day, a twenty-three-year-old journeyman printer, broke with this genteel tradition by introducing the first daily newspaper to sell for one penny, the *New York Sun*. By relying solely upon street sales and advertising (and forgoing financial support from political parties or the government), Day reduced the daily's price, as well as its size—from the "blanket sheets" that ran upward of two by three feet to a nine-by-twelve-inch paper that could easily fit within one's pocket. Within three months, the *Sun* had a circulation of five thousand copies, becoming the most popular paper in New York. City Two years later, it had the largest circulation in the nation, bought by some 20,000 readers every day, a figure that doubled by 1840.

Day thus enlarged the community of readers who incorporated newspapers into their cultural diet. His success relied upon external developments as much as his ingenuity. Innovations in transportation, including the paving of streets, the completion of city blocks, and the advent of gas lighting (first adopted by Baltimore in 1817 and installed in New York by 1825), promoted street sales, while improved shipping and rail lines sped the arrival of raw materials. New printing technologies also played a critical role. Using bleached rags to produce paper (hence the term "rags" for the papers) and a mechanical system of rotating

cylinders to increase its hourly output, the *Sun* was able to outsell its competitors. Finally, an expanding literate public supplied a brimming market of readers always hungry for news and seeking ways to make sense of the city's swirl of events. These developments enabled the success of other "penny pioneers," such as Arunah Sheperson Abell and William Swain, who together founded the *Philadelphia Public Ledger* in 1836, and James Gordon Bennett, who, after working for the *Sun*, launched the *New York Herald* in 1835, a paper distinguished by its graphic images reproduced from woodcuts that depicted current events.

Like the minstrel show, the penny press first appealed to working-class audiences, largely because its publishers came from the working class themselves. Penny presses peddled salacious gossip and human-interest stories, and they advertised products that served everyday life. Their writers mined police reports and court records to reveal scandal and hypocrisy among well-known politicians or celebrities and to satirize a sanctimonious middle class and aristocratic snobs. The editors of Philadelphia's *Public Ledger*, for example, distinguished the paper from "those dull papers who have the arrogance to neglect the masses" who represented hard work rather than the "indolence, luxurious ease" and moral laxity of the idle rich. In the urban world of strangers, the penny press helped its readers distinguish between friend and foe, the real and the fake, and to partake in an expanding community of readers. Newspaper accounts of personal lives could provide a substitute for authentic human contact, enabling a sense of familiarity and sympathy. By fulfilling the role of village gossip, the penny press directed its coverage to people on the streets, not just the rich and powerful.

The sensational ax murder of the prostitute Helen Jewett provided the very sort of fodder that fed sales of the penny press. On April 10, 1836, Jewett's body was discovered in the bed of an upscale brothel in New York City, struck three times in the head with an ax

and badly charred from fire. Within a short time, authorities arrested a dry goods clerk, Richard Robinson, age nineteen, whose trial became a press circus. Each day, spectators and reporters lined up outside the courtroom, hoping at least to see Robinson, a privileged young man whose father had served in the Connecticut legislature. Some youthful clerks became his fans, packing the courtroom wearing the page-boy caps that Robinson wore, and roaring in approval when the suspect was acquitted for lack of evidence. The crime went unsolved, but Jewett's murder invited multiple interpretations. While six-penny publications for affluent readers chose not to cover this "disgusting" tale, the various penny dailies embellished the gore and scandal to sell competing interpretations, maximizing sales among a heterogeneous readership, while also affording readers the opportunity to decide the matter for themselves.

No one marketed this opportunity better than Phineas Taylor Barnum, a New York entrepreneur from a well-off Connecticut family who pioneered a new national culture of celebrity and showmanship. As a young man, he settled in the Bowery district, taking a job as a clerk in a dry goods store. He frequented taverns and gambling dens and developed his own distaste for the "codfish aristocracy" who snubbed poor New Yorkers with scorn and pity. In 1825 he quit his job and joined the itinerant "hawkers and walkers" who trudged the countryside with acts and exhibits ranging from animals to peep shows and freaks. His career as a showman began with a particularly audacious exhibit, Joice Heth, whom Barnum touted as "the Greatest Natural and National Curiosity in the World," natural because of her alleged age of 161 and national because of her supposed connection to George Washington, who, Barnum claimed, was cared for by Heth in his infancy. Barnum advertised her as "the first person who put clothes on the unconscious infant who ... [would lead] our heroic fathers to glory, to victory and freedom." Audiences debated the authenticity of Barnum's exhibit, and Heth, for her part, revealed her own theatrical talents, playfully engaging audiences by

repeating her claim to have raised "dear little George" to one audience after another.

With Heth, Barnum discovered the mass appeal of the "humbug," or hoax, enthralling audiences who relished the opportunity to distinguish the real from the fake. Barnum mastered the art and business of "humbuggery" when he purchased John Scudder's fledgling American Museum in New York for the sum of $15,000 in 1841. Until that point, museums remained vehicles for learning and for cultural uplifting, usually the pet projects of wealthy patrons like Thomas Jefferson and Charles Wilson Peale, who established museums to foster civic-mindedness and intellectual curiosity in the new republic. Like the penny pioneers who recognized the untapped potential of a working-class market, Barnum broke with genteel traditions by borrowing from an emerging class of "dime museums," charging ten cents admission and featuring an eclectic collection of bizarre and sensational exhibits. Barnum combined heavy advertising, lavish decoration, and intense controversy to bolster his new enterprise. Within three years, the American Museum housed perhaps as many as 30,000 items, including waxworks, suits of armor, weapons, and a huge menagerie of live animals from land and sea. It combined the zoo, the aquarium, the natural history museum, the circus, the freak show, the lecture hall, and the art gallery. Between 1841 and 1865, this institution drew in an estimated 38 million customers who paid 25 cents for admission.

Its most renowned attractions were on the second floor, where Barnum staged his "freaks" or "human curiosities," as he called them, mostly live exhibits that blurred the boundaries between entertainment and politics with great fanfare and controversy. Take "Clofullia, The Bearded Lady," a Swiss-born hirsute woman discovered by Barnum in the 1840s and displayed in the American Museum as "A Woman with a Beard? Impossible! It Must Be a Man." Viewers of the time came to this exhibit steeped in a broader gender dysphoria. On the one hand, women were earning new public visibility through their outspoken stance against

slavery or alcoholism. The Grimké sisters, Angelina and Sarah, packed lecture halls around the country, delivering impassioned lectures against the horrors of slavery, much like the eloquent speeches of Lucretia Mott, Elizabeth Cady Stanton, and other women, many of whom participated in the first women's rights convention at Seneca Falls, New York, in 1848. Their public stand, however, sparked outraged for defying popular ideals of femininity. As an expanding middle class embraced these ideals, and as some women boldly defied them, Clofullia arrived at the American Museum with a two-inch beard and a diamond tiara, inviting audiences to debate the nature of "true womanhood."

Clofullia sat alongside "The Feejee Mermaid," a renowned exhibit that featured the head of a young monkey sewn onto the body of a fish, preserved in a jar of formaldehyde, which Barnum promoted as half mammal, half fish, or the mummified version of a mermaid. Drawing upon a European tradition of mermaid exhibition, Barnum claimed that his "crittur," as he called it, was taken alive from the "Feejee Islands" and encased in the American Museum around 1842. While it furthered accusations of Barnum as a fraud and a huckster, especially in its tour of the South, the Feejee Mermaid also prompted discussions about science and its new authority in antebellum culture. "Who is to decide when the doctors disagree?" Barnum asked, inviting the public to test its ability to evaluate, verify, and explain what science could not. Barnum defended this and other "humbugs" as the very nature of the new market economy; "in what business is there not humbug?" he asked, emphasizing shenanigans as the modern way of doing business. Indeed, the "market revolution" of the first half of the nineteenth century looked like a humbug to many contemporary observers: a new, complex, and opaque system of market relations rife with unpredictable fluctuations and mediated by disembodied economic relationships. In this new context, the Feejee Mermaid seemed both strange and familiar to audiences who were just beginning to recognize the deception built into an impersonal market economy.

Barnum tapped into the racial uncertainties of the antebellum period as well with a notorious exhibit, "What Is It?" For this display, which arrived at the American Museum in 1860, Barnum found William Johnson, a developmentally disabled African American man whom Barnum dressed in a fur suit and promoted as either a "lower order of Man" or a "higher order of Monkey," leaving it to the public to decide. "What Is It?" debuted three years after the Supreme Court issued its infamous ruling in *Dred Scott v. Sandford*, which held that persons of African descent could not be U.S. citizens and therefore had no standing to sue in court, and that the federal government, not the states, would regulate slavery. *Dred Scott v. Sandford* intended to settle the question of slavery's future in an expanding republic. Instead, it fueled the moral thrust of the abolitionist movement and set the stage for the Civil War. At this time in the nation's history, "What Is It?" invited white spectators to debate the humanity of African Americans and their status in an expanding republic where whites ruled entirely.

Like working-class theater, Barnum's American Museum helped to birth a modern mass culture. Although the museum itself was located in New York, its fame extended throughout a largely rural but rapidly expanding nation, thanks to new national circuits of advertising, publicity, and promotion. Its far-reaching reputation contributed to the development of modern notions of celebrity and bolstered a rising tourist industry, which flourished with the expansion of a national railroad network. Barnum pioneered a new inclusive brand of mass entertainment that blurred the boundaries not only between social classes and ethnic divisions, but also between entertainment and politics, art and commerce. His museum welcomed public debate and judgment, and it opened scientific debates and political controversies to public scrutiny, regardless of wealth and social status. Barnum's oft-repeated maxim, "let the public decide," signaled his identification with a political culture that celebrated the common man and amplified his voice.

Barnum's huckster brand of showmanship, however, did not play well in the white South. There, the development of honor codes governed relations between the sexes and stressed the importance of personal reputation. These shared codes of the southern gentry required gentlemen to display strength, honesty, and chivalry toward women, and they expected chastity and fidelity from women. As subordinates and inferiors, black women and black men stood outside the southern culture of honor, though their status as slaves supported the honor of white men. On plantations, white masters could reinforce local conceptions of their honor through ritual acts of degradation and humiliation. With their emphasis upon honesty and integrity, southern honor codes thus provided an unwelcoming environment for Barnum's humbugs, or anything that smacked of deceit, lying, or hoax. Even baseball, with its coded signals and stealing bases, did not gain traction in the South until well after its initial popularity in the North during the 1840s.

African Americans also influenced a regionally distinct culture of the South, even under the brutalities of slavery. The Baptist and Methodist churches, for example, provided an institutional context for a new African American spiritual community with its own interpretation of the Bible that emphasized exodus and freedom from slavery. Christian slaves also invented their own style of worship that incorporated traditional forms of African spirituality, including call and response, rhythmic singing, and vocal improvisation. African Americans developed a rich cultural life outside of the church as well: voodoo, for example, drew upon African and French-Catholic traditions of sorcery, herbal medicine, and fortune telling in Louisiana. Folktales, especially animal trickster tales from Africa in which weaker animals outwit or overcome stronger ones, provided instructional allegories passed on from parents to children—lessons on how to convey resistance and provide comfort. Outside the demands of fieldwork, slaves also established expressive styles of festive dress and dance, usually displayed with great fanfare on Sundays or on

traditional holidays. Ex-slaves also added their own thrust to the abolitionist movement by writing slave narratives, the most famous being that of Frederick Douglass, whose *Narrative of the Life of Frederick Douglass, an American Slave* (1845) described in compelling detail the horrors of slavery and black aspirations for freedom. These written and oral forms of expression furthered the development of a new syncretic, African American identity, affirming black community and resistance to slavery.

The discovery of western lands and peoples also inspired new forms of cultural expression during the antebellum period. Between 1823 and 1841, the five novels of James Fenimore Cooper's *Leatherstocking Tales* chronicled the life and times of Natty Bumppo, a renegade frontiersman, half white, half Indian, who embodied the clash of cultures. Though Cooper himself had little contact with Indian peoples, he created a frontier archetype who lived among stereotypes of "good" and "bad" Indians, not unlike the real-world figure of Daniel Boone, the Kentucky frontiersman mythologized by biographers and artists as the embodiment of rugged individualism and heroic adventure. *The Leatherstocking Tales* is widely recognized for its contribution to the indigenous origins of a national literature, one that emerged during the westward thrust of a young, expanding nation.

While most Americans could not afford their own adventures in the American West, they could see its image through the work of a number of artists, who conveyed the scenic wonders of western lands and the distinctive lifeways of its original inhabitants. Drawing on a conviction that Indians constituted a "vanishing race," artists strove to capture their authentic image for historical posterity. George Catlin created an "Indian Gallery" through his detailed portraits of Great Lakes Indians that toured the United States and Europe, and Charles Bird King produced studio portraits of more than 100 Indians, compiled into the three-volume *The History of Indian Tribes of North America*, sponsored by the U.S. Office of Indian Affairs.

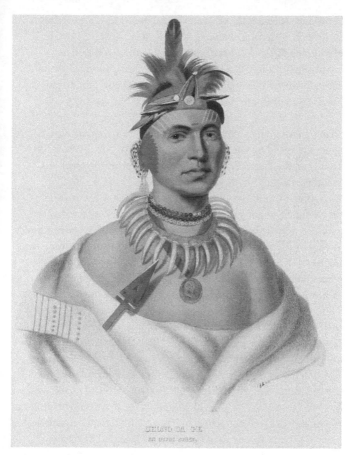

4. A hand-colored lithograph of "Chono Ca Pe. An Ottoe Chief," by Charles Bird King, was one of more than 100 portraits published in *History of the Indian Tribes of North America* (1837–1844). Sponsored by the U.S. Bureau of Indian Affairs, the project reflects a government effort to preserve the image of an allegedly "vanishing" race.

Other artists won acclaim for their exaggerated, dramatic portraits of western scenery. German-born Alfred Bierstadt traveled west with government surveyors in the 1850s and 1860s

to produce spectacular portraits of the Rocky Mountains that enthralled both American and European audiences. English immigrant Thomas Moran, similarly, ventured west on an expedition for the U.S. Geological Survey and produced stunning portraits of the Yellowstone area of Wyoming, helping to persuade Congress to preserve the area as a national park in 1872.

Such images made a powerful case for westward expansion, just as newspapers did on the eve of the Mexican-American War in 1846. That year, the journalist John O'Sullivan coined the term "manifest destiny" to describe the young nation's fate to "overspread the continent allotted by Providence for the free development of our yearly multiplying millions." As an ideology, manifest destiny fueled the expansionist thrust of American policy toward Mexico, and it supported a racialist view of Mexicans as a "mongrel" people driven by savage instincts and unfit for self-government. It reignited long-standing prejudices among Protestants toward Catholics and introduced a Christophilic triumphalism, an interpretation of American history that begins with Columbus's "gift" of civilization to indigenous peoples. German American artist Emmanuel Leutze dramatized this interpretation in his 1843 painting, *Columbus before the Queen*, which depicts Columbus kneeling before the court of his royal patrons, and similarly in his 1848 work, *Storming of the Teocalli by Cortez and His Troops*, which renders the Spanish assault upon the Aztec capital of Tenochtitlán. Leutze's historical perspective had parallels in the work of the early professional historian William Prescott, whose *History of the Conquest of Mexico* (1843) argued that the Aztec lineage of Mexican people cultivated a penchant for violence that stymied aspirations for modern democracy.

The Mexican-American War brought California into the Union, a state that claimed the promise of the American West through new channels of mass communication. In 1840, Richard Henry Dana published his account of his voyage to California from Boston in

Two Years Before the Mast, a best-seller that sparked national interest in the West Coast and its prospects for settlement. Some eight years later, the discovery of gold in the foothills of the Sierra Nevada Mountains unleashed a global stream of words and images about California, mostly advertisements that lured migrants by land and sea from virtually every continent on earth. If newspapers and periodicals boasted the promise of striking gold in California, journals, letters, and diaries record the bitter legacy of conflict and disappointment left behind. Images of the California Gold Rush circulated widely in photographs, lithographs, etchings, and wood engravings, bolstering a myth of the state as an earthly paradise. While San Francisco rose as a thriving metropolis by the 1880s, Los Angeles remained but a dusty frontier outpost. But,that town's connection to a transcontinental railroad link in 1876 altered its destiny.

Local boosters advertised the region's warm, arid climate, sandy beaches, and orange groves, and they capitalized upon its Spanish or "Mediterranean" past to sell the image of an exotic retreat from small-town drudgery and urban chaos. Millions of Americans, especially those suffering from infectious diseases such as tuberculosis and aging Midwesterners, flocked to Los Angeles in the latter decades of the nineteenth century, fueling the growth of a city built upon a mass-marketed myth of health, wealth, and sunshine. The induction of California into the Union augmented a new national consciousness, rife with conflict and contradiction; while it realized expansionist dreams of a nation that stretched from "sea to shining sea," it also raised new questions about the frontier's closing and the fate of American democracy.

Chapter 3
The age of the city, 1860–1900

In June 1874, city officials in New York gathered in Central Park, then only seventeen years old, to dedicate a bronze statue, "The Seventh Regiment Citizen Soldier." Frederick Law Olmsted, the park's designer, personally chose the site for the statue at the corner of 69th Street and West Carriage Drive, where John Quincy Adams Ward, hailed by the *New York Times* as the "dean of American sculptors," dedicated his statue of a Union soldier from New York City's 7th Regiment. Standing upon a granite pedestal with rifle in hand, the soldier bears the likeness of stage actor and dramatist James Steele MacKaye, who had served in the 7th Regiment and later posed for Ward in his studio.

The event took place in the aftermath of the Civil War, a bloody conflict between North and South that spurred a united impulse to commemorate the lives lost and to coordinate that effort with new campaigns for civic beautification. It also reflected the emergence of the urban park, a descendant of the garden cemetery, as a new urban space that debuted in cities throughout the United States. It demonstrated not just the rise of a homegrown art establishment in the United States, which set aside Europe's classical traditions in favor of a new American focus, but also, perhaps, the new fluidity of personal celebrity, from the theatrical stage to a plinth in Central Park.

More than anything, it tells us about the making and experience of the modern city, which rose to dominate late-nineteenth-century American culture and society. Historians describe this period as "the Gilded Age," an age of rapid economic growth marked by robber barons, rampant speculation, labor strife, and gross inequality. On the streets of American cities, the new titans of industry—Carnegie, Rockefeller, Mellon, Huntington, Crocker, Morgan, and others—sponsored the construction of new monuments and statues and endowed lavish facilities for parks, cemeteries, railroad stations, universities, museums, libraries, office buildings, hotels, private clubs, and apartment houses. Yet this monumental display of sumptuous wealth hid new depths of poverty and squalor, as well as new heights of social unrest.

In this tumultuous environment, amidst noxious congestion and radical diversity, amidst a second industrial revolution that took off after 1870, a new set of cultural experiences and institutions provided a semblance of order against a backdrop of conflict and chaos. Such order reflected the rise of a new oligarchy, but it also entailed a promise to integrate workers and immigrants into civil society and the body politic and into the racial norms of American whiteness as well. The new urban culture of the late nineteenth century spilled beyond the city into the countryside, introducing new goods and services, new images and ideas, to a nation that closed its frontier and realized its dream of manifest destiny.

In terms of lives lost, the Civil War remains the costliest war in American history. An estimated 750,000 Union and Confederate soldiers died, and another 50,000 civilians perished in epidemics of disease and violence. Though the war ended slavery and emancipated some 10 million African Americans, it also left a bitter legacy of sectional conflict and racial inequality, which lingers to the present. The war is well known through the lens of military and political history, but cultural historians study the war's *representation* through contemporary words and images. Newspapers, for example, provided journalistic accounts of military

battles and casualty lists, drawing the attention of anxious families and friends of soldiers in combat. In larger cities, crowds gathered around telegraph offices to read postings of the latest news bulletins.

Handwritten letters, to and from soldiers, increased the bulk of the U.S. mail, a product of higher literacy rates among both Confederate and Union soldiers. Americans could also see portraits of the war through lithographed engravings and drawings printed in pictorial magazines like *Harper's Weekly*, *New York Illustrated News*, and, most especially, *Frank Leslie's Illustrated Newspaper*, which had expanded its weekly readership to almost 350,000 by 1860. Most of all, photographs visualized the front lines of battle for civilians in the North and the South. Matthew Brady, Alexander Gardner, and others compiled a visual record of the conflict, rendering the human cost of war in graphic new displays. Their stark portraits of mangled bodies strewn across a battlefield became familiar to Civil War Americans, the first generation to witness war through the lens of a camera.

Collective tributes to the war began in earnest during the 1870s and 1880s, in towns and cities of the North, South, and West, when civic-minded citizens, cooperating with public officials and war veterans, commissioned sculptors, architects, and landscape designers to commemorate the war and its legacy. In 1877, civic officials dedicated the Sailors and Soldiers Monument in the Boston Common, a neoclassical column sculpted by Martin Milmore. In 1891, the Louisiana Historical Society opened the Confederate Memorial Hall Museum in New Orleans, the first Civil War museum in the United States. And in 1895 the establishment of a national military park in Gettysburg, Pennsylvania, commemorated the Union's decisive victory in 1863 and President Lincoln's famous address. The nation's first cemetery for veterans, Gettysburg served as a model of a landscape resembling Mt. Auburn Cemetery designed by botanist and landscape architect William Saunders.

Mt. Auburn's influence was also felt in New York, where an alliance of ministers, educators, journalists, social workers, architects, landscape designers, artists, and their wealthy patrons undertook a new experiment in urban recreation: a major public park that could provide both a space for relief from the mounting pressures of rapid urbanization and a democratic venue for social mixing. At least this was how the park's designers, Frederick Law Olmsted and Calvert Vaux, imagined Central Park when they won a design commission to build on 800 acres of land in central Manhattan in 1858. Drawing upon English landscaping traditions, Olmsted and Vaux sculpted a picturesque landscape of meadows, woods, rolling hills, ponds, lakes, fountains, and meandering roads, an idealized setting that would "enable men to better resist the harmful influences of ordinary town life and to recover what they lose from them." While boosters and journalists celebrated the park's democratic character and its status as a place where all social classes could mix, the park developed class-specific patterns of use as early as the 1860s, when wealthy New Yorkers defined the park as their own. As such, Central Park became many parks, with ample ground to partition the recreation of separate and unequal social classes.

Central Park received up to 10 million visitors per year by the 1870s, by which time its proper use engendered sharp debate. For his part, Olmsted complained about a "certain class" of visitors who "are ignorant of a park... .They will need to be trained to the proper use of it, to be restrained in the abuse of it." He and his associates called for a special park police force, the Park Keepers, who would enforce a host of new regulations that proscribed climbing trees, molesting birds, racing carriages, destroying plants, walking on the grass, and shooting firearms. These and other restrictions helped to enforce the illusion of an elevated landscape, above the run of ordinary life, much like the sunken traverse roads that carried vehicular traffic across the park at 65th, 79th, 85th, and 97th Streets.

Central Park presented a didactic model of social order and constructive leisure, a park to inspire, refine, and uplift. It also sparked criticism from other civic voices who demanded more opportunities for public recreation and entertainment—sporting fields, racing tracks, merry-go-rounds, tree climbing, concerts—and who ridiculed the park's custodians as prissy. In 1877, the *New York Evening Express* characterized Olmsted's supporters as "Miss Nancies" who "babble in the papers and in Society Circles, about aesthetics and architecture, vistas and landscapes, the quiver of a leaf and the proper blendings of light and shade." Still, Central Park influenced an entire generation of civic leaders and boosters in many other cities to adopt imitations, launching a national urban park movement.

The promoters of urban parks helped to shape an emerging dominant culture in the United States, one that began earlier in the nineteenth century with middle-class reform efforts and that reached the heights of its influence in its final decades. Like Olmsted, the self-appointed representatives of "respectable" society took a ministerial posture toward edifying the urban masses of immigrants, workers, and families, answering their call to cultural leadership, to discipline, to elevate and instruct, and to model the values of industrial productivity—hard work, temperance, self-control, sober earnestness, frugality—for the citizenry at large. While managers and supervisors could enforce such values on the job, the growing availability of leisure time aroused concerns about the many vices that threatened their inculcation, particularly gambling, prostitution, and alcohol. These genteel reformers mobilized American arts and letters to disseminate "correct" values, in line with the demands of wage labor and factory work. This meant targeting poetry, fiction, music, or the visual arts, not for art's sake, but rather for moral and social uplift. It also meant aligning with a rising class of commercial taste-makers who produced a slew of inexpensive books, periodicals, catalogs, engravings, lithographs, and photographs. Harnessing innovative technologies of mass production, this alliance assumed

cultural leadership by promoting the value system of industrial capitalism.

A chromolithograph from 1875, "The Ladder of Fortune," illustrates that very system. Crafted by printmakers Nathaniel Currier and James Merritt Ives, the image provides an allegory in the portrait of children in a verdant park setting, looking upon a ladder that leans upon a tree. Each rung of the ladder bears the name of a particular virtue—industry, temperance, economy, punctuality, integrity, courage, perseverance, morality, honesty, and prudence—that leads to life's rewards—success, riches, reputation, good will, honor, and influence—depicted as fruits hanging from the tree's branches. In the background is a distant city, with crowds of men surrendering to the temptations of vice, the stock market, betting, strikes, and alcohol. The children and their guardians stand in the foreground of the image, eager to avoid corruption.

One element here deserves attention. Unlike "honesty" or "courage," "punctuality" had a particularly modern resonance, one with scant traces in the cultural history of traditional societies. The nineteenth century introduced a new sense of time, based upon the accelerated pace of industrial production. The pre-industrial experience of time depended upon seasonal harvests, religious festivals, or family occasions, for example, but the rising factory system of wage labor and mass production demanded the self-inculcation of new time discipline, imposed upon a newly formed working class, composed mostly of rural migrants and immigrants. Such discipline was enforced not only by the incessant sounds of railroad whistles and factory bells, but also by the installation of clocks in factories and train stations, and upon city streets and buildings as well.

The new speed of commerce, moreover, enabled through recent technological advances such as the telegraph and transcontinental railroad, demanded a wholesale restructuring of national time.

The adoption of standardized time zones by the federal government in 1918 simply marked the recognition of a practice already in use by railroad companies as early as the 1880s. Nineteenth-century Americans adjusted to this new time discipline not just through their close proximity to clocks big and small, but also through the creation of new stories to impress the importance of punctuality upon the nation's youth.

The moralizing culture of Gilded Age America targeted, in particular, youth, who learned the protocols of industrial capitalism through schoolbooks and short stories. The *McGuffey Readers*, for example, appeared in American schools beginning in the 1860s. Recognized for his authority in moral and biblical subjects, William Holmes McGuffey wrote a series of children's textbooks, or "readers," that included stories, essays, and poems, usually with inspirational messages that encouraged patience and perseverance. Similarly, Horatio Alger penned a string of "rags to riches" novels for young adults in the second half of the nineteenth century. His 1868 volume *Ragged Dick* became a best-selling novel with its tale of a poor young bootblack who rose to middle-class respectability through hard work, punctuality, and frugality. When the hero rescues a drowning child, he is rewarded with a new suit and a job in a mercantile firm. With that, Ragged Dick becomes Richard Hunter, Esq. and is "cut off from the old vagabond life which he hoped never to resume."

Ragged Dick and *The Ladder of Fortune* epitomize the "gospel of success" as Gilded Age Americans imagined it. This narrative took shape during the maturation of industrial capitalism in the late nineteenth century, and while it ignored the harsh inequities that accompanied this turbulent phase of economic growth, it linked dedication to hard work with making money and money to moral character. "What is the chief end of man?" Mark Twain asked in 1871. "To get rich. In what way? Dishonestly if he can, honestly if he must. Who is God, the one and only true? Money is God." Twain's sarcasm aside, his observation explains why most

Americans admired the dynamic new class of industrialists such as John D. Rockefeller, J. P. Morgan, Cornelius Vanderbilt, and other "gods" of the second industrial revolution. Andrew Carnegie embodied the late-nineteenth-century infatuation with the "self-made man" who rose from humble, immigrant origins to achieve fame and fortune. Carnegie, a ruthless businessman, oversaw the expansion of the U.S. steel industry, becoming the richest man in the world by 1900.

Carnegie dedicated much of his fortune to philanthropy, endowing libraries, colleges, universities, and museums. But he amassed his wealth in espousing the ideas of Herbert Spencer, the British philosopher who formulated social Darwinism, an intellectual movement that applied Charles Darwin's biological ideas of natural selection to society in postulating that unfettered free enterprise ensured the survival of the best and strongest elements of society. Thus, if Carnegie and Rockefeller overcame their competitors, if they bought out smaller and weaker businesses, they had simply proved themselves the fittest to enjoy wealth and power. Linked to a Protestant ethic that recognized wealth accumulation as a sign of God's favor, social Darwinism underwrote the new morality of the Gilded Age, blaming poverty upon the innate deficiencies of poor people themselves.

Yet social Darwinism, however fashionable among wealthier segments of society, had its critics as well. American sociologist Lester Ward, for example, attacked the ideas of Herbert Spencer in his 1883 treatise, *Dynamic Sociology*, arguing that corporate monopolies stifled opportunity and individual potential. Ward's contemporary, economist Henry George, who had gone west from Pennsylvania to California in the 1850s, wrote *Progress and Poverty* in 1879, describing how the monopolization of land by railroad corporations, not inborn deficiencies, pushed the vast majority of Californians into economic dependency, if not into abject poverty. His best-selling book inspired popular demands for land reform, as did utopian novels like Edward Bellamy's *Looking*

The age of the city, 1860–1900

Backward (1888), which described an urban industrial world of the year 2000, a world without private land ownership—the very opposite of the Gilded Age extremes of class exploitation, exclusion, and excess.

A more trenchant critique of the crass materialism of Gilded Age society came from social scientist Thorstein Veblen, born in Wisconsin to Norwegian immigrants, who earned his doctorate at Yale in 1884. In *The Theory of the Leisure Class* (1899), Veblen identified the spending habits of the rich as "conspicuous consumption," criticizing the new tendency to show off accumulated wealth in an urban setting. With a keen sociological eye, Veblen diagnosed the insecurities of a nouveau riche who relied upon the display of material possessions to manifest taste, power, and prestige.

Yet such display had broad appeal for an expanding mass of urban consumers, flush with new disposable income and increasingly dependent upon the convenient availability of manufactured products. Their growing appetite for clothing and household goods fueled a new experience of mass consumption, concentrated within a rising downtown urban core. The American department store had transatlantic roots in the *grands magasins* of Paris in the 1860s. These establishments were grand emporiums of merchandise equipped with electric lights, elevators, and fans, well before electrification entered the American home. In Europe and the United States, the new department stores revolutionized the experience of shopping, with fixed, low prices and no haggling, a money-back guarantee, a high volume of goods, and an open invitation to shop with no obligation to buy. These temples of merchandise became sightseeing destinations in their own right, like Marshall Field's palatial State Street address in Chicago, completed in 1907, with its domed ceiling containing 1.6 million iridescent pieces of Tiffany glass. While the rise of the department store crushed the livelihood of local merchants who represented the city's older, more localized economy, it also expanded the

workforce, especially among women, who cultivated a welcoming environment for women shoppers.

The department store heralded a new culture of mass consumption in the late nineteenth century. Mail-order catalogs abetted this development, putting a world of consumer goods within reach of rural areas and small towns for the first time. In 1885, the U.S. Post Office drastically reduced rates for shipping bulk mail, and the dedication of special mail cars on newly built transcontinental rail lines enabled shoppers at home to purchase sewing machines, lamps, clothing, and firearms from such mail-order companies as Sears, Roebuck and Company, which delivered goods within a few weeks. Advertising emerged as a critical component of mass consumption, stoking consumer desire through graphic new images of consumer pleasure and corporate products, reproduced through color lithography. By the 1870s, advertising became an industry in its own right, when new independent agencies such as Louis Prang began securing corporate clients who hired the firm to market new products and brands. Bright colors, bold script, and ornate images of sumptuous luxury defined the new look of mass consumption, one that seeped into every aspect of a national print culture.

Advertising emerged as the art of capitalism, an aesthetic tied to the free-market production and consumption of consumer goods. As with other cultural expressions of the time, advertising helped to shape popular perceptions of different social groups. Women and their bodies appeared frequently in early advertising, tied to a wide variety of products and services. Depicting women as nurturing mothers or as voluptuous sirens, early print advertising circumscribed women within a two-dimensional ideal of femininity designed to induce sales. Early advertising also confirmed ideas about racial difference, featuring pervasive images of Indian warriors and black mammies, tying portraits of race to white spending power. At the end of the nineteenth century, other advertisements evoked fantasies of colonialism and

The age of the city, 1866–1900

55

empire. Pear's Soap, for example, ran an 1899 advertisement in *McClure's* magazine, depicting Admiral George Dewey, who defeated the Spanish in the Battle of Manila during the Spanish-American War, washing his hands, with a background image of a missionary handing a bar of soap to a dark-skinned native. Quoting the title of Rudyard Kipling's 1899 ode to U.S. imperialism, the advertising copy extolled this brand of soap as "the first step toward lightening the White Man's Burden," and necessary for "teaching the virtues of cleanliness" in the "dark corners of the earth."

White Americans held ambivalent feelings toward race in the nineteenth century, sentiments that were captured within popular novels of the age. Even as the Reconstruction era saw a vicious white backlash against black freedom in the South and the North, African Americans appeared as the faithful companions of benevolent white characters in the best-selling novels of the century. Eva St. Claire's affection for her father's slave Uncle Tom, for example, the eponymous hero of Harriet Beecher Stowe's *Uncle Tom's Cabin* (1852), dramatized the common humanity between blacks and whites. Mark Twain's *Adventures of Huckleberry Finn* (1884), similarly, rendered the emotional bonds between a white boy, Huckleberry Finn, and his companion Jim, a runaway slave. Helen Hunt Jackson took the theme of interracial bonding to romantic extremes. Her 1884 novel *Ramona* enthralled readers with the story of an ill-fated romance between Alessandro, a "San Luis" Indian from Southern California, and Ramona, a "half-breed" of Indian/Scottish descent. Their tragic love affair, set amidst the picturesque ruins of Spanish Catholic missions, spawned a nascent tourist industry in Southern California and provided a sentimental alternative to the more racist and bombastic narratives of westward expansion. These stories, first arriving in serial form in magazines, entertained the possibility of interracial affection and romance for an expanding white readership who reaped the benefits of slavery, segregation, and territorial conquest.

Slavery notwithstanding, popular attitudes toward race hardened a powerful boost in the late nineteenth century, when American scientists invented a new language of racial difference. Racial science emerged through the work of Swiss-born Harvard botanist Louis Agassiz, who abandoned scripture to embrace the theory of polygenesis, the idea of human races as separate species with separate origins. In Philadelphia, physician Samuel George Morton conducted experiments on the skull sizes of different racial groups. A pioneer of the pseudo-science of "craniometry," which purported to measure the intelligence of racial groups through skull size, Morton determined that the "Teutonic family" of Germans, English, and Anglo Americans ranked highest in cranial capacity, above the "Mongolian" and "American" [Indian] racial groups, and farthest above the "Negroid" group, which ranked the smallest in skull size. Agassiz and Morton were not the sole practitioners of the new racial science, but historians later found evidence of preexisting bias and an "unconscious finagling" of data, producing skewed results that affirmed white assumptions and stereotypes. But in the aftermath of the Civil War, racial science helped to heal the divide between the white North and the white South, explaining racial inequality as the result of inherent differences in intellect and aptitude.

Like the minstrel show of the antebellum period, the racial science of the Gilded Age contributed to a sense of order in a society wracked by upheaval and flux. This sense also surfaced in a new language of cultural hierarchy, which accompanied the widening class divide in late-nineteenth-century America. The Astor Place Riot of 1849 foretold of this new order, as working-class patrons protested their exclusion from a lavish new theater that became a prototype for a new rarified realm of "high culture." By the 1880s and 1890s, Americans increasingly classified, or ranked, culture as "high" and "low," adopting the very language of racial science with its designations of "highbrow" and "lowbrow," drawn from Morton's descriptive analysis of human skulls. Such cultural cleavages enabled elites to signify their elevated status in an

anonymous and polyglot urban society. Amassing vast fortunes through monopolistic control over mining, shipping, railroad, and manufacturing industries, the upper strata of urban society grew eager to affiliate, exclusively, with the classical traditions of the Old World, whether in art, music, theater, or architecture.

This meant a new partitioning of audiences by class. Whereas early antebellum theater catered to inclusive audiences with a mixed fare of Shakespeare's works, orchestral music, and opera, these performances were increasingly experienced in isolation from each other by the late nineteenth century, segmented within exclusive new institutions dedicated to a singular artistic performance. Gone were the "farces" performed in between acts—jugglers, singers, dancers, or acrobats—as were the rambunctious crowds, who learned awe and restraint in these new temples of high culture. Shakespeare ascended into a new canon of "polite" theater, while opera also lost its connection to a shared culture, repackaged as foreign-language performances in such rarified venues as the Academy of Music and the Metropolitan Opera House, which were deeply influenced, if not controlled, by wealthy patrons. The museum underwent a similar transformation, departing from the miscellany of Barnum's American Museum to more specialized displays of historical artifacts, scientific discoveries, or the "fine arts" that brought endowments and prestige.

The segmentation of the arts in late-nineteenth-century America reflected the categorizing zeal of a new American aristocracy, anxious to combat the city's disorienting mix of races, ethnicities, nationalities, languages, and religions. Such heterogeneity threatened the cultural dominance of Anglo-Saxon elites, driving their effort to build exclusive institutions that enshrined a new canon of artistic work. The museum, the concert hall, the opera house, the university—these institutions enshrined Eurocentric ideals of cultural superiority, enabling holders of old money and nouveaux riches alike to signify their elevated status over the city's unrefined masses.

New technology also fueled the need for such distinctions. The mass reproduction of art images through chromolithography, the process by which original paintings were reproduced in mass-produced color prints and sold to millions of consumers, sparked concerns about the spread of a "pseudoculture" that produced "a society of ignoramuses," as the critic E. L. Godkin wrote in *The Nation* in 1874. Photography further stoked such fears, which not only promoted the mass reproduction of original works of art, but also democratized the means of *creating* art. The invention of Kodak #1 camera in 1888 by George Eastman of Rochester, New York, a simple and affordable apparatus for taking pictures, made snapshot photography available to millions of amateurs who possessed no technical expertise or aesthetic training. Mechanization and mass production thus revolutionized the role of art in a rapidly urbanizing society. On the one hand, it democratized its production and enjoyment among wider segments of the population, while, on the other, it also sparked concerns about the leveling of cultural differences and the loss of authentic experience.

If the modern city fostered the spread of an inauthentic, machine-made "pseudoculture," the western frontier remained a powerful symbol of release from the confines of an overcivilized society. Yet the closing of the frontier by the 1890s generated acute anxieties about the loss of a democratizing force in American culture and the rising specter of socioeconomic inequality and labor conflict. Frederick Jackson Turner, a historian at the University of Wisconsin, articulated this perspective in his "frontier thesis," describing the "exceptional" character of Americans and their unique democratic experiment. Breaking with the European-origins story of American history, Turner argued, in *The Significance of the Frontier in American History* (1893), that, in the course of westward expansion, Americans developed a unique set of traits—individualism, informality, democracy, and initiative—that fostered the rise of a new national power. Turner ignored the role of conquest, capitalism,

and patriarchy in the settlement of western lands, but he legitimized a durable, and highly marketable, myth of the frontier in American history.

While Turner worried about the closing of the frontier, a new showman, a Barnum of the American West, invented a wildly popular myth of "how the West was won." William F. "Buffalo Bill" Cody's Wild West Show, an elaborate stage production with a cast of hundreds, blended myth, ideology, patriotism, history, and showmanship to enact action-packed scenes of life in the "Old West," dramatizing archetypal frontier scenes such as Pony Express rides, Indian attacks on covered wagons, stagecoach robberies, and a reenactment of Custer's Last Stand. Cody, himself a product of the frontier, claimed historical accuracy and authenticity for his productions, stating his goal was to educate as much as to entertain. The Wild West Show included humorists like Will Rogers, sharpshooters like Annie Oakley, and frontiersmen like "Wild Bill" Hickok as well as "real" Indians like Sitting Bull and Geronimo, famed warriors who spent their last days playing foil to Cody and his cast.

In 1884, the Wild West Show added its grand finale, "Attack on Settler's Cabin," a stage drama of pioneer women and children trapped inside a burning cabin encircled by whooping Indians; at the last moment, Buffalo Bill and his cowboy friends save the day, freeing the hostages inside. Just when the Dawes Act enabled the federal sale of Indian lands, Cody's Wild West Show portrayed Indians on the losing side of history, or on the sidelines of manifest destiny and its pageantry. Touring North American and European cities (Cody even performed before Queen Victoria on the occasion of her jubilee in 1887), the Wild West Show emerged by the time of its conclusion in 1916 as the largest and most successful business in American commercial entertainment. It also established a lasting legacy, inspiring the creation of a western genre of film, radio, and television in the twentieth century.

The Western lore of Cody and Turner drew packed audiences at the World's Columbian Exposition in Chicago in 1893, a world's fair designed to commemorate the four hundredth anniversary of the arrival of Columbus in the Americas. Philadelphia had held the nation's first world's fair in 1876. Some four decades later, American cities had hosted twelve expositions, attracting more than 100 million visitors. These fairs served as venues for cities to show off their economic strength and technological progress, to boost growth and development, and to advertise corporate products housed within pavilions for industry, commerce, and agriculture.

The Chicago fair was one of the most lavish ever created. The exposition expressed the vision of a social and cultural elite eager to re-create society in its own image. An alliance of businessmen, bankers, lawyers, property developers, and real estate promoters pooled their resources to mount a grandiose display that aimed to showcase Chicago's progress and the nation's development. Backers charged architect and urban planner Daniel Burnham with orchestrating a unified design, one that coordinated the efforts of the nation's most prominent artists, architects, and landscape designers, most of whom were trained at the Ecole des Beaux-Arts in Paris, where they learned the neoclassical style. Like Central Park, the fair's section known as the White City had a didactic function to elevate and inspire, yet its vision was urban, a model of the ideal city as the embodiment of symmetry, clarity, and harmony.

The White City was born in less than two and a half years on a lakefront site in Chicago's Jackson Park, lordly in scale, blindingly white, and with a central "Court of Honor" lined with arches, colonnades, lagoons, fountains, canals, and classical sculpture. Floodlights illuminated the scene at night, presenting the image of a dream city to the visiting throngs. On closer inspection, the gleaming white marble of the exposition turned out to be staff, a compound of plaster and fibrous binding lathered onto wood and

steel frames that were quickly dismantled after the fair's conclusion. Nonetheless, the fair's designers and wealthy patrons meant to offer an enduring lesson and an uplifting alternative to the chaos and squalor of the real Chicago.

A total of 21,480,141 visitors from throughout the nation and from abroad visited the White City during its four-month run between May and August 1893. Burnham's White City presented a model of social cohesion for a divided people and a highly influential model of urban recreation in the late nineteenth century. Its monumental scale and classical design reflected the didactic posture of a new urban elite bent on civic uplift and the display of "correct" taste and genteel standards. The White City also provided a new national template for civic architecture and urban design. The City Beautiful Movement of the early twentieth century applied the designs of Burnham's fair to the emerging urban landscape, inspiring a new geography of monumental civic plazas and sweeping thoroughfares, punctuated by such grand public structures as city halls, train stations, libraries, and universities. For all its influence, the White City marked a fitting end to the nineteenth century, a century of dynamic growth and material progress. Such prosperity, however, was not shared equally. For many Americans, it remained an illusion, much like the White City itself.

Chapter 4
The new mass culture, 1900–1945

The White City represented lofty ideals of a utopian world, an ordered alternative to the chaos and squalor that defined the contemporary urban scene. But for a restless urban public steeped in the raucous pleasures of minstrelsy, Barnum, and Wild West shows, it was not enough. Visitors to the White City complained of an overwhelming sense of boredom. Even Frederick Law Olmsted noted the "melancholy air" of the fair and wrote to the park's designers to suggest adding "more incidents of vital human gaiety." Belatedly and reluctantly, exposition officials authorized the construction of the Midway Plaisance, a mile-long appendage to the White City that featured carnivalesque sideshows, ethnographic displays, saloons, and mechanical rides—a concession to the crowd's appetite for physical sensation, sexual titillation, and just plain fun.

The Ferris wheel debuted at the Midway, an electrical machine built in the service of human pleasure, not material production. This contraption, like the Midway itself, symbolized a profound shift underway in American culture at the turn of the twentieth century—a move away from the Victorian ideals of the industrial era and toward a new set of values structured by a corporatizing economy. As an overflow of manufactured goods spilled outward from industrial centers, a new consumer ethic, pushed by a burgeoning advertising industry, exhorted men and women to

indulge their growing spending power and leisure time. Having fun, looking good, and keeping up with the increasingly rapid cycles of trends and fashions became the order of the day, and expenses for these items became familiar to a younger generation of working men and women, eager to spend their disposable income on the commercial pleasures of urban life.

The early twentieth century witnessed the birth of a new mass culture, an extension of developments already underway, but one that was unique in its capacity to envelop heterogeneous multitudes within new technologies of sight and sound. Cinema, advertising, and radio dominated this new cultural landscape, stretching from Madison Avenue in New York to Los Angeles, where Hollywood was born. This period witnessed the rise of a new class of entrepreneurs, largely of European immigrant origins and much more in tune with working-class sensibilities than with the white, Anglo-Saxon, Protestant (WASP) elite and its genteel traditions. As the Old World order crumbled in Europe and as the United States welcomed new immigrants into its fold, these entrepreneurs, mostly men, mastered new technologies of mass communication and new patterns of corporate organization to forge a "culture industry." Like the corporate producers of automobiles and cigarettes, the manufacturers of entertainment amassed astounding fortunes, even in the depths of the Great Depression, while affording new possibilities for personal expression and public behavior.

Although Chicago's exposition planners built the Midway Plaisance as an afterthought, perhaps they heeded a lesson from Philadelphia, where the Centennial Exposition in 1876, in all its grandeur, spurred the adjacent development of "Centennial City," an unplanned stretch of restaurants, small hotels, beer gardens, ice cream parlors, and small shows along Philadelphia's Elm Avenue. This flimsy shantytown, built willy-nilly by entrepreneurs looking to make a fast buck, also featured dioramas, peanut stands, pie-stalls, sausage vendors, candy shops, and the inevitable balloon man. One of the most popular

attractions was a museum that advertised its display of "the wild men of Borneo, and the wild children of Australia, the fat woman ... and a collection of 'Feejees,' described as 'pure and unadulterated man-eaters.'"

Taking its cue from Centennial City, the Midway Plaisance packaged its raucous entertainment within a hodge-podge of elaborately decorated stalls, tents, and booths. Stage shows featured singers, dancers, comics, and novelty performers. Mechanical rides delivered physical sensation and sensory pleasure, while barkers enjoined visitors to see "the wonders of the Maharaja," "the three legged-man," and, most shocking, the "hootchy-cootchy dancers." The Midway also included ethnographic displays that depicted foreign peoples in their allegedly native habitats. The official guidebook for the 1893 World's Fair promised visitors "civilized, half-civilized and savage worlds to choose from," packaging the world's diversity along a symbolic axis. Walking from the White City into the Midway, one would first find the "Teutonic" and "Anglo Saxon" races, represented by two German and two English villages. Beyond these installations, at the center of the Midway, stood the Chinese village, the Japanese village, as well as the Algerian and Tunisian villages, where belly dancers and sword swallowers performed for visitors.

At the farthest end of the Midway stood the American Indian Village and the "Dahomey Village," a stand-in for "darkest Africa," with African Americans hired to pose as native Africans in jungle costumes. On the occasion of White City's "Colored People's Day," the single day on which African Americans were allowed entry into the exposition, Frederick Douglass, the fugitive slave who remained a leading voice for black civil rights at the turn of the twentieth century, condemned the Dahomey Village: "as if to shame the Negro, the Dahomians ... exhibit the Negro as a repulsive savage." The sequestering of blacks and Native Americans within the marginal space of the Midway thus served to whiten White City's whiteness.

The Midway provided white fairgoers, immigrant and native alike, with an outlet for release, a break from White City's imposing scale and genteel pretentions. Like Centennial City, Chicago's Midway repackaged a "tenderloin culture" that burgeoned within the vice districts of American cities from San Francisco to Boston. These areas, generally the habitat of laborers, immigrants, prostitutes, drinkers, actors, gamblers, crooked cops, and confidence men, cradled an alternative moral universe outside the social norms of middle-class moralists and snobbish elites who built expositions in their own self-image. They became the focus of a new realist strain in American culture, a reaction, in part, to the overly sentimental and expressive forms of romanticism.

A number of artists, including John Sloan, George Bellows, and others, explored the grit of New York at the turn of the twentieth century, depicting factories, boxing matches, saloons, tenement houses, train stations, and other aspects of everyday life. The works of the "Ashcan" school, as these artists came to be known, debuted alongside the realist fiction of writers like Stephen Crane, Theodore Dreiser, and Frank Norris, as well as the "muckracking" brand of investigative journalism that brought public attention to corporate monopolies, political corruption, and urban poverty. What distinguished this body of work was not just its artistic and literary technique, but also its core focus on the problems and prospects of urban industrial life.

Another New York artist loosely affiliated with the Ashcan School (in fact mentored by John Sloan) was Reginald Marsh, who found inspiration in the city's new landscapes of mass amusement. Marsh's eye followed the crowds to Coney Island, the first amusement park in American history and the direct descendant of the Midway. Alongside an assortment of hotels, bathhouses, and clam bars along the Atlantic Ocean shore of Brooklyn, the promoter George Tilyou built Steeplechase Park in 1897, an enclosed area of rides, shows, and concession stands, similar to

the Midway's attractions. His success inspired developers Frederic Thompson and Skip Dundy to open Luna Park across the street from Steeplechase in 1903, a "storybook land of trellises, columns, domes, minarets, lagoons, and lofty aerial flights," as the *New York Times* reported. At night, 250,000 light bulbs, the largest number ever assembled at one site, transformed Luna Park into an electric fantasy world that added its own sparkle to a burgeoning skyline. A third amusement park, Dreamland, opened at Coney Island in 1904, outshining Luna Park with one million electric light bulbs. With two enormous Shoot-the Chutes rides that were built side by side, a model reconstruction of Venetian canals, and a miniature railroad that ran through a Swiss Alpine landscape and a "Lilliputian Village" occupied by some 300 dwarf inhabitants, Dreamland offered a fantasy world that presented an illusion of escape from the everyday world.

Every weekend, tens of thousands of working-class men, women, and children came to Coney Island by train, ferry, or subway. They waited in line to board rollercoasters and Ferris wheels and to climb towers to behold spectacular views of New York City and the Atlantic Ocean. They enjoyed the cheaper amusements of shooting galleries and fortunetellers, or they reveled in the anonymity of a ten-block area known as the "Gut," where dance halls, brothels, dog-fighting arenas, and saloons enticed patrons. Accommodating huge crowds, Coney Island introduced a new mass culture that flourished with the proliferation of amusement parks across the country, whose appearance often reflected collaboration between real estate developers and transit companies, which built rail lines to promote patronage. Boston's Paragon Park, Philadelphia's Willow Grove, Atlanta's Ponce de Leon Park, St. Louis's Forest Park Highlands, San Francisco's The Chutes, and Los Angeles's Pacific Ocean Park—these and other amusement parks accommodated diverse multitudes of workers and consumers, eager to indulge in a carnival world that provided a pleasant, temporary release from the stringent demands of an urban industrial society.

In no small part, Coney Island's pleasures were sexual. At Coney Island men and women could be found mingling with each other on the beach, clad only in bathing suits; falling into the arms of strangers on rides like "The Barrel of Love" and "The Human Roulette Wheel"; measuring the intensity of a kiss on the "Kiss-o-Meter"; and partnering with strangers of the opposite sex in the dance halls of Dreamland and Luna Park. The amusement park surged with an erotic energy that young men and women had to repress in other contexts of their lives. Its invitation to erotic pleasure, moreover, also included same-sex forms of attraction. The Washington Baths, for example, were reputed to be a haven for men seeking intimacy with other men. Police reports and memoirs from the time document the homosexual encounters that transpired within the loosely supervised spaces of the Washington Baths, part of an all-male subculture that flourished within Coney Island's saloons, brothels, and gambling houses.

Sexual behavior aside, Coney Island belonged to a new physical culture that emerged at the turn of the twentieth century, one focused on the pleasure and performance of the body. A new "dance madness," for example, swept across the nation in the early twentieth century, rooted in the expressive cultural traditions of black America. Ragtime music and popular dances like the cakewalk and the turkey trot drew white men and women, working class and middle class alike, into a nighttime world of cabarets, nightclubs, and dance halls. Spectator sports enjoyed a new popularity in the early decades of the twentieth century, whether through the organization of professional leagues for baseball and football or through the growing interest in intercollegiate competition. Early-twentieth-century novels also reflected a new interest in physical vigor and exciting experiences. Owen Wister's *The Virginian* (1902) described the life of cattle ranching in Wyoming; Jack London's *Call of the Wild* (1903) offered a sled dog's account of the Yukon gold rush; and Edgar Rice Burroughs's *Tarzan of the Apes* (1912) introduced one of the best-known literary characters in the world. These stories and

others were part of a larger cultural shift away from genteel codes of formality and self-control, and they pushed the boundaries of physical sensation and public pleasure.

This shift also entailed experimentation with gender roles, departing from the nineteenth-century cult of domesticity. Bodybuilders like Eugen Sandow, magicians like Harry Houdini, baseball legends like Babe Ruth—even mythic heroes like Tarzan—displayed the male body as an object of physical beauty and inspired new idealizations of white manhood, set against anxieties about the emasculating effects of urban modernity. Women, moreover, especially immigrants and workers, took advantage of the anonymous and unsupervised spaces of the new mass culture to pursue autonomy and creative self-expression. Among the growing constituency who frequented cheap urban amusements, young women, often in the company of their peers from the office or the neighborhood, independently pursued their cravings for leisure, romance, and fun. Increasing numbers of women also entered the burgeoning world of the theater as working actors. Sarah Bernhardt, Fanny Brice, and other women became stars in their own right, commanding top salaries by pioneering new models of femininity onstage. In their brash display of wit, sexuality, and self-promotion—on and off stage—these women flaunted their break from older codes of femininity and served to model popular idealizations of the "New Woman."

These cheap amusements tapped into new markets—both within the urban middle class and within the largely untapped working class, who earned their right to leisure and pleasure. Their commercial nature, racial restrictions notwithstanding, enabled greater inclusivity—a swelling mass of white consumers otherwise diverse by class, religion, language, gender, and ethnicity. And their affordability—fifty cents for a ball game, ten cents a ride at Coney Island, twenty-five cents for admission to a dance hall, sometimes free for women—ensured access for a broader swath of consumers. Yet such pleasures, despite their working-class origins,

soon enticed high society, which surrendered its aloof posture to revel in the bustle of an expanding urban nightlife.

Essentially, this trajectory explains the origins of Hollywood and the mass popularity of film, which inherited the tenderloin culture of the Midway, the hootchy-cootchy atmosphere of Coney Island, and the new technology of photography and electricity. Before a small group of studio executives in Hollywood invented the modern motion picture industry, working-class men and women, both those who spoke English and those who did not, went to penny arcades to peer into a kinetoscope, an early motion picture device invented by Thomas Edison for individual viewership. This gave way to the Vitascope, another Edison invention that projected images from a strip of film (a French invention) onto a blank wall or screen. People could now watch films as an audience inside the Nickelodeon, a storefront space, devoted exclusively to film projection. By 1908, some 8,000 theaters had opened along this model, charging five-cents admission, a sum considerably cheaper than the price of a ticket to the theater.

Usually located in downtown commercial districts or in working-class immigrant neighborhoods, nickelodeons supplied a novel form of "poor man's amusement." With minimal cash outlays and low overhead, nickelodeons were inexpensive to establish and maintain; thus, they proved attractive to immigrant entrepreneurs seeking a niche within the commercial structure of the metropolis. Cheap and everywhere available, the movies quickly dominated the leisure time of working-class audiences. One survey in New York City in 1910 found that 72 percent of movie audiences came from the blue-collar sector, 25 percent from the clerical workforce, and 3 percent from the "leisured classes." Initially, filmmakers shot footage of anything that moved—trains, horses, dancers—but they soon geared their product toward a new brand of "working-class cinema," depicting the conditions of life for America's workers with wit, humor, satire, and a good deal of foul language, nudity, and sexual contact. Thus, thoroughly integrated into the leisure

time of working class-audiences, nickelodeons sometimes became venues for unionizing efforts and campaigns by the Socialist Party.

But that changed quickly. As filmmaking adopted more sophisticated techniques and as its popularity soared across the nation, it assumed a corporatized structure that amassed vast new fortunes, while arousing public concern about the moral impact of movies upon the public. The popularity of the movies among youth and women especially inflamed the indignation of religious groups such as the Catholic Church, whose leaders aggressively campaigned against what they saw as immoral film content. Their ire prompted studio executives to adopt a self-imposed list of industry moral guidelines, "Don'ts" and "Be Carefuls," that constituted the Motion Picture Production Code, which regulated motion picture content between 1930 and 1968. A more moderate class of reformers during the Progressive era, more out of concern for public safety, targeted the space of the nickelodeon itself, advocating for ample seating, air circulation, aisles, lobbies, and emergency exits. Facing public pressure on multiple fronts, film producers and exhibitors realized they had to clean up their act, even if they did not have to follow blue laws or accept government censorship, as the Catholic Church had advocated. So, by forming trusts like the Motion Pictures Patents Company in 1909, establishing respected brand names like Biograph or Vitagraph, introducing new techniques of filmmaking, or glorifying the individual stars and their personalities so loved by audiences, a nascent film industry built a cultural empire by successfully gearing its product toward mass consumption on a global scale.

By the mid-1920s, the most profitable film studios, as part of their promise to clean up their act, began opening luxury theaters within the downtown quarters of American cities. The movie palace, endowed with an opulence once known only at the courts of emperors, pharaohs, monarchs, and popes, scoured examples of the world's styles of architecture to conjure a fantasy world of exotic luxury. Adopting Egyptian, Aztec, Moorish, Gothic,

Chinese, Byzantine, or Renaissance design motifs, the movie palace of the 1920s rejected the formality of neoclassicism and brought the eclecticism of midways and amusement parks to the theater districts of American cities. The rinky-dink nickelodeon stood no chance against these lavish new venues, replete with uniformed ushers, neon marquees, red carpets, sparkling chandeliers, gilded mirrors, and potted palms that mimicked Old World opulence. Although the price of admission increased, from five cents to around fifty cents, and up to a dollar in some cities, these palaces for the people reflected the new wealth of the American film industry and offered an inclusive new venue that drew movie fans from all classes.

Welcome to Hollywood, a suburb of Los Angeles that by the late 1920s had emerged as the capital of moviemaking. Movies were neither invented nor popularized in Los Angeles, but with a rudimentary film industry in place by the early teens and with city boosters aggressively courting film studios, offering generous tax incentives, weak unions, a temperate climate, and free land in some instances, motion picture production eventually concentrated in Southern California. Hollywood thus came to signify a regional film culture that took shape not just around movies and the movie palace, but also around movie premieres, movie publicity, and, most of all, the movie star, whose life off screen—in the hills and canyons of Hollywood and Beverly Hills—won much publicity and adoration. Film stars of the 1920s—Charles Chaplin, Clara Bow, Mary Pickford, Rudolph Valentino, Douglas Fairbanks, Gloria Swanson—enthralled movie fans with their youth and lavish lifestyles, on screen and at home. They defined a new ideal of glamour that sold newspapers and magazines, and they advertised the commodities that symbolized status, romance, and leisure to millions of Americans.

This new focus on celebrity and affluence accompanied the new corporate orientation of Hollywood, which by the late 1920s had developed financial ties to Wall Street. By this time the investment

company Goldman Sachs, for example, was pouring over $850 million annually into Hollywood studios, establishing a financial lifeline between New York and Los Angeles. By the 1930s, Hollywood reached the heights of its economic and cultural power through the maturation of the studio system, virtually a corporate monopoly over motion picture production. The major motion picture studios, Paramount, Fox, Metro-Goldwyn-Mayer, Warner Brothers, Columbia, United Artists, Universal, and RKO, known collectively as the "Big Eight," assumed vertical forms of integration by consolidating all aspects of filmmaking—production, distribution, exhibition—under a single corporate roof. Essentially, each studio owned a core stable of directors, actors, screenwriters, editors, and cinematographers, who worked under contract for a powerful class of studio executives. These men—Louis Mayer, Lewis Selznick, Harry Warner, Adolph Zukor, Carl Laemmle, and others—were all Jewish immigrant entrepreneurs who began their careers in the commercial trades of New York and Chicago.

Their Jewish immigrant origins speak to the inclusivity of the new mass culture, as well as to the more fluid social structure of twentieth-century Southern California. A man-made improvisation itself, Los Angeles maintained a capacity for self-reinvention that enabled some marginal groups to overcome traditional social barriers. Los Angeles certainly had a WASP elite, but its mark upon the city's culture and identity was less pronounced than in older American cities. A city founded upon the aggressive promotion of myth and fantasy, Los Angeles provided an ideal setting for Jewish immigrant entrepreneurs who sought to assimilate into the mainstream of American culture. While Los Angeles sheltered a more familiar immigrant community of working-class, Yiddish-speaking Jews on its east side, the Hollywood Jews of the west side adopted a more cosmopolitan, consumerist outlook, well attuned to the trends and fashions that stoked public desire. Thus Carl Laemmle, a German Jewish immigrant to New York who later opened Universal

Studios in the San Fernando Valley of Los Angeles in 1915, chose Spanish design motifs for his studio lot and named his trade journal *The Melting Pot*.

As the capital of the new mass culture, moreover, Hollywood provided a heterogeneous mass of Americans a means by which to integrate, at least momentarily, into the mainstream of American culture. The stars who dominated the screen in the 1920s and 1930s modeled powerful idealizations of white masculinity and femininity—they looked and spoke like "real" Americans—always with the help of studio technicians who skillfully used light, clothing, cosmetics, and editing to create a visual appeal that found mass reproduction in newspapers, fan magazines, and postcards. Their image inspired millions of consumers, especially immigrants, to erase the stamp of individual neighborhoods and ethnic communities to join a larger social whole—a new "American" public doing "American" things. Like amusement parks, dance halls, ballparks, and vaudeville houses, Hollywood broadened the appeal of the new mass culture by creating a national audience of movie fans, diverse by language, religion, ethnicity, class, and gender.

But not race. Once again, race provided the essential fiction that assimilated diverse consumers of European heritage into a homogenous white audience. In both form and content, the institutions of the new mass culture appealed to the racial sensibilities of white Americans and to those who aspired to that identity. Few black faces, for example, can be found in photographs of the frolicking masses at Coney Island, while many southern amusement parks prohibited the admission of African Americans altogether. A Coney Island concession stand, "Hit the Nigger—Three Balls for Five," inspired a slew of imitators throughout the nation, such as Kansas City's "Coontown Plunge" or Chicago's "African Dodgers." In the ballpark, where white players successfully excluded blacks from the professional leagues, segregationist policies kept black spectators in the worst seats,

while "pickaninnies," "coons," and "nigs" paraded as mascots on the field. Although black musical traditions elevated the dance hall's popularity, African Americans, paradoxically, were barred from the dance floor.

Most of all, however, Hollywood, through its expansive reach, enforced a new color line in American culture. Movies glamorized white skin through visual techniques of lighting and editing; movie theaters enacted policies of segregated seating and film studios barred African Americans from employment. In their storylines, movies affirmed ingrained notions of racial hierarchy through racist stereotypes and caricature. Celebrated films like D. W. Griffith's *The Birth of a Nation* (1915) depicted the Ku Klux Klan as heroes in the turbulent times after the Civil War, and *The Jazz Singer* (1927) revived the minstrel tradition as a vehicle for Jewish assimilation. Though film historians recognize these films as important precursors of the feature-length sound film, their portraits of race and race relations belied the democratic inclusiveness of the new mass culture.

African Americans, nonetheless, like other racial groups, shared the nation's enthusiasm for movies and found ways to circumvent Hollywood's staunch racism. Black film producers such as George Johnson and Noble Johnson established their own production facilities, working with black directors like Oscar Micheaux, black actors such as George R. Garner Jr. and Evelyn Preer, and black businessmen, who opened their own movie theaters in the black neighborhoods of New York, Chicago, and Los Angeles. This infrastructure fed a parallel market of black movie audiences who flocked to such "race films" as *The Homesteader* (1919), which trumpeted an "All Star Negro Cast." Like African Americans, Mexican Americans also faced exclusion and misrepresentation in Hollywood, but they forged their own film culture centered on both American-made and imported Mexican films, which found new markets in U.S. cities with substantial Spanish-speaking populations.

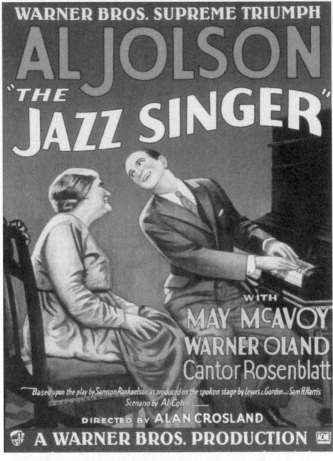

5. The first feature-length film with sound, *The Jazz Singer* (1927) enthralled American audiences with the story of young Jake Rabinowitz, the son of a Jewish cantor who struggles to launch a career in show business. The film revived the minstrel tradition for film audiences and ended the silent era of the 1920s.

Black Americans found other means of cultural expression during the period between the world wars. The Harlem Renaissance, that explosion of arts and letters from upper Manhattan between World War I and the mid-1930s, brought black artists—writers, painters, scholars, photographers, poets, and musicians—into a vortex of cultural creativity, fueled by a thriving urban economy that made New York the capital of the 1920s. Zora Neal Hurston, Jean Toomer, Arna Bontemps, Langston Hughes, Claude McKay, and others made up a pantheon of gifted artists and writers who explored the black experience in America. Many of these men and women had come from the South, fleeing a repressive racial caste system and seeking a freer environment in which to express talent, ideas, opinions, and experiences. Much of their work appeared in *The Crisis*, a magazine that gained the height of its renown during the 1920s under the editorship of W. E. B. DuBois, the historian, philosopher, and activist of race in America. This periodical and its featured writers drew white praise and recognition, but it also cemented a foundation for black racial activism, an expression of the "New Negro" from outside of the South, demanding civil and political rights through cutting-edge literary work and setting the stage for a racial revolution.

Black musical traditions, in fact, define a lasting interpretation of America in the 1920s. Novelist F. Scott Fitzgerald dubbed the decade the "Jazz Age," describing it as a cultural revolution, a period marked by a rebellion against sexual and moral conventions, when men and women flaunted the laws, indulging in drink, celebrity, flapping, slumming, and bootlegging in pushing the boundaries of youthful innocence. For many white Americans of the middle and upper classes, these were the characteristics of the time, though not everyone could indulge in the moment. Farmers and low-skilled workers saw a net decline in their wages, while consumers racked up credit debt and occupied overvalued real estate.

Many black Americans remained trapped in structures of poverty and segregation, but their cultural voice resonated across the

decade—through the musical talents of Louis Armstrong, Bessie Smith, Jelly Roll Morton, Duke Ellington, Ella Fitzgerald, and Count Basie, the pioneers of jazz who drew upon the musical traditions of minstrelsy, ragtime, and the sounds of the brass bands of New Orleans. With no written score, jazz musicians improvised, embellishing the melody as they went along. This new sound flourished in the illicit environment of urban speakeasies, often ruled by Italian American gangsters who put black musicians on their payrolls and paid them a decent wage. "Hot jazz" won broad appeal among urban audiences, white and black, American and non-American alike. While the executives of record companies were reluctant to sign on, convinced that white listeners preferred white musicians, jazz found its place in history as a uniquely American invention, a hybrid of traditional African and urban American influences.

Jazz enthralled European audiences as well, especially in cosmopolitan capitals like Paris and Berlin. At the same time, Europeans reciprocated as part of a widening pattern of transatlantic cultural exchange. During the 1930s, for example, German Jewish screenwriters, directors, and actors came to Hollywood to make sound pictures and to escape the specter of looming war. Ernst Lubitsch, Fritz Lang, Bertolt Brecht, Arnold Schoenberg, Billy Wilder, and others arrived in the movie capital, bringing their cosmopolitan sensibilities with them and helping to instill a dynamic public culture of cafes, restaurants, and nightlife in a city that revolved around private home life. Movie stars like Marlene Dietrich and Greta Garbo personified new models of feminine sexuality and furthered Hollywood's openness toward sexual expression. By the early 1940s, Hollywood had become a Berlin in exile, hosting some of Europe's most celebrated artists and intellectuals.

Despite the hardship and uncertainty unleashed by the Great Depression, the American culture industry thrived during the 1930s. This was the golden age of radio, which reached the

consumer market in the 1920s and, in the 1930s, rivaled cinema as a staple form of mass entertainment. Soap operas, musical performances, talk shows, and religious programs dominated the airwaves, with national networks such as the Columbia Broadcasting System and the National Broadcasting Corporation amassing vast fortunes from advertisers who paid top dollar to announce their brand names. Radio also emerged as a new form of political communication during the years of the Great Depression. From a broadcasting studio in Detroit, for example, the xenophobic radio priest Father Charles Coughlin built support by railing against Jews, communists, Wall Street bankers, and the New Deal itself. Louisiana senator Huey P. Long used radio to advocate his "Share Our Wealth" program, which proposed a radical redistribution of wealth. Most famously, however, President Franklin Roosevelt's "fireside chats" introduced a new intimacy between the people and their president, helping to soothe the traumatic effects of a national depression and building support for new social welfare programs.

Even as the United States endured the worst economic depression in its history, and as clouds of war darkened over Europe, American culture developed a sophisticated infrastructure, national and international in scope, fed by a vast input of human imagination and creativity. It included some striking paradoxes brewing within the culture. While artists, writers, and intellectuals found vital new outlets for creative expression, they also felt alienated by the slick commercial apparatuses that marketed their work as cheap, disposable commodities. Walt Disney films, notably *Snow White and the Seven Dwarfs* (1937), delighted audiences with brilliant animation and comedic farce, but they also depicted a dark side rife with evil, terror, and the macabre. Shirley Temple radiated childhood joy and innocence on the movie screen and *Superman* enthralled comic book readers with superhuman strength, but monster films like *Dracula* (1931) and *King Kong* (1933) gave shape to darker anxieties about national collapse and financial ruin. The realistic portrait of America's

downtrodden—in the fiction of John Steinbeck or the photography of Dorothea Lange, both of whom rendered the extremes of white rural poverty in the Dust Bowl migration to California, clashed sharply against Hollywood's stylized portraits of Jean Harlow, Clark Gable, and Cary Grant, golden icons of an affluent and materialistic society. Between the grim realities of depression and war and the yearning for distraction, Americans of the Great Depression era turned to their culture for comforting answers to troubling questions.

There were also occasions for critical self-refection. The actor, director, writer, and producer Orson Welles, for example, played a trick on radio listeners in his theatrical adaptation of H. G. Wells's science fiction novel, *The War of the Worlds*. On the eve of Halloween 1939, Welles and a cast of actors simulated a live news bulletin coverage of a Martian invasion of central New Jersey, spurring panic among listeners who did not realize they were tuned in to another segment of *The Mercury Theater on the Air*. Though Welles faced some criticism and much praise for this stunt, his broadcast raised new questions about radio's capacity for mass deception and social control. Nathanael West explored a similar theme in his novel *The Day of the Locust* (1939), a sordid tale of aspiring nobodies, struggling has-beens, and jaded movie fans in Hollywood in the 1930s, exposing the cruelty of an industry that never delivers on its glittering promise of romance, wealth, and leisure. Welles, West, and others challenged Americans to think critically about their relationship to the new mass culture and to question its influence upon society.

Much of Welles's work in film, radio, and theater belonged to a new "cultural front" in America in the 1930s, which included a new artistic and literary focus upon working people and a new workforce of artists and writers who expected economic justice. This front included magazines like *The New Masses* (1926–1948) which featured trenchant essays, poems, photographs, and cartoons, all focused on workers' lives and struggles. Many readers

of this magazine also formed John Reed Clubs, named after the American communist who produced *Ten Days That Shook the World* (1919), an eyewitness account of the Bolshevik Revolution. Sponsoring lectures and art exhibits, organizing writing workshops, and debating the prospects of a socialist revolution in America, club members associated informally, often in the bars and cafes of cities across the nation, which were strongest throughout the industrial corridor of the Midwest and Northeast. The cultural front also included the employees of radio stations and film studios—artists, technicians, designers, writers, and others willing to strike for higher wages and fair benefits. The 1941 animators' strike at Walt Disney Studios in Burbank, California, ranks among the most publicized episodes of class conflict in twentieth-century America, drawing nationwide attention to the strife seething within the very home of Mickey Mouse.

Participants in the cultural front of the 1930s maintained a global outlook, inspired by the workers' revolution in Russia and by workers' struggles abroad. They also viewed the rise of fascism in Germany and Japan with alarm, and they generally supported the nation's effort to defend democracy. World War II temporarily checked the class conflicts of the previous decade, rallying labor, capital, and government into a unilateral defense of the American way of life. "Buy American" became a familiar refrain during the early 1940s, as corporations and government exhorted consumers—black and white, men and women—to buy war bonds and other American goods and services, tying consumer spending to the defense of democracy itself.

As wartime manufacturing surged, so did the mass production of new stories that held a mirror to wartime struggles. The image of Rosie the Riveter pervaded the pages of magazines and catalogs, extolling the American women who took over from enlisted men factory jobs making bombs, planes, and ships. Norman Rockwell's iconic portrait, featured on the cover of the

Saturday Evening Post on May 29, 1943, depicted a muscular woman in overalls with a rivet gun in her lap and a copy of *Mein Kampf* crushed beneath her boot. The print culture of wartime America also included a slew of racist caricatures, targeted at Germans and Japanese, whose warped imagery appeared in cartoons, advertisements, and films. The American government asserted its presence in the mass media, establishing the War Advertising Council and the Office of War Information to keep the public abreast of wartime developments and rally support for the nation's troops.

The early 1940s introduced the "pin-up girl," modeled by actresses like Rita Hayworth and Betty Grable, who dressed down for photographs distributed to hundreds of thousands of soldiers on the war front. While these images aroused fantasies of an explosive "bombshell" femininity, the war also invited men to experiment with their masculinity. While the G.I. became a popular figure in the gendered culture of the early 1940s, personified by showmen like Frank Sinatra, Bob Hope, and Bing Crosby, the zoot suit style debuted within a bustling urban nightlife of music halls and jazz clubs. Sporting long double-breasted jackets, high-waisted, baggy pants, and wide brimmed hats with feather accents, so-called zoot suiters appeared as the symbolic opposite of the G.I. Though both civilian and soldier adopted a uniform of sorts, the zoot suit symbolized a rebellious new masculinity, replete with a heavy dose of macho swagger, adopted by young working-class men of color and conspicuously at odds with the war effort and its call to patriotism and sacrifice.

The zoot suit perplexed contemporary onlookers, who struggled to solve the "riddle of the zoot," as the mid-century writer Ralph Ellison described this curious figure. The fact that young, working-class black, Chicano, and immigrant men popularized this fashion suggests its appeal among disaffected youth, who sought to defy wartime expectations and maintain a sense of creative autonomy against the dehumanizing experiences of racism and wage labor.

Such fashion among young men of color provoked the racist impulses of white servicemen. Beginning in Los Angeles in June 1943, white servicemen stopped, stripped, and beat young Chicano, black, or Filipino men wearing zoot suits, inspiring similar incidents in cities across the nation, from San Diego to Harlem. These race riots broke out during a period of racial upheaval in wartime America and signaled the power of fashion to construct alternative, even subversive, identities sufficient to provoke a violent backlash with racist conviction.

Chapter 5
The suburbanization of American culture

Americans had much to celebrate after their government made good on its threat to wipe out two major Japanese cities with the apocalyptic firepower of nuclear fission. With the dropping of the atom bomb, World War II came to its gory conclusion, the most destructive war in human history, leaving the United States to emerge as the world's dominant superpower, inaugurating a golden age of prosperity and abundance. The national nightmare of depression and war were over, affording time to enjoy the comforts of domestic normalcy.

Yet the cultural record of that moment belied the cause for optimism. Beginning in the mid-1940s Hollywood dispatched a new cycle of crime dramas, cinematic tales of murder, grift, violence, and mayhem. Weak, passive men and conniving, tough-talking women inhabited this film genre, loitering the streets of dangerous, dilapidated, and very dark cities. Often seen through the shadow lines of a Venetian blind, this nighttime world dramatized the very opposite of the American dream, a claustrophobic maze of brick and neon overrun by psychopaths, con artists, and cold-blooded killers.

Film noir, a new genre of American film, debuted in the age of white flight, when white Americans, often the children or grandchildren of European immigrants, pursued opportunities for

work and housing in newly developed suburban communities that maintained formal and informal policies of racial exclusion. As they followed newly built superhighways that led away from the city, they left growing pockets of racial poverty in their wake— what became the modern ghetto, or, in the urban Southwest, the barrio. New crime dramas, dubbed *film noir* ("black film") by two French film scholars, which depicted the moral crisis of urban life through innovative visual strategies, debuted in this context. As the first "suburban" genre of American popular culture, film noir demanded safe and orderly alternatives to the menace of the modern city. Yet while the suburbs provided a shiny new setting for theme parks, shopping malls, television, drive-ins, fast foods outlets, supermarkets, parking lots, and freeways, the cities nurtured the growth of creative subcultures, even as they bore the brunt of federal policies that favored suburban development. While film, broadcasting, and publishing executives trumpeted their patriotism during the Cold War, often in audacious ways, postwar American culture registered a new set of spatial and racial tensions and codified a new suburban way of life.

After the turmoil unleashed by depression and war, Americans, though confident about their standing in the world, looked ahead with anxiety and trepidation. The generation that had seen it all wondered if it could happen again: shuttered banks, bread lines, rationed goods, evil empires, genocide, enemy attacks, and nuclear holocaust. Film noir, with its brooding storylines, lurid mix of sex and violence, and decisively unhappy endings, seemed appropriate for the jaded palate of war-weary Americans, who weathered the 1930s and early 1940s on a saccharine diet of musicals and screwball comedies. They were indeed ready for a return to normalcy after the war's conclusion, but not without a look back to the places they left behind.

World War II revolutionized American society. It brought women into the workforce in unprecedented numbers. It brought blacks into the cities of the Northeast, the Midwest, and the far West.

Diverse American men and women mixed in all sorts of ways during the 1940s: on the shop floor or on the front lines, even on the dance floors, where swing jazz brought black musical traditions into the mainstream of American culture. The modern city, pulsing with industrial productivity, framed these encounters, bringing newfound independence to workers, consumers, and soldiers, stoking their expectations for full equality.

Film noir delivered a cinematic backlash to this social upheaval. Its portrait of women, for example, exhibited a deeply misogynist streak. Film noir reintroduced the femme fatale to American culture, personified by Joan Crawford and Barbara Stanwyck, actors who played viragos overstepping gendered and moral boundaries to seduce meek but lustful men like Fred MacMurray in *Double Indemnity* (1944) or Burt Lancaster in *Criss Cross* (1949). Film noir also inflamed the racial consciousness of white Americans by dramatizing the seedy charm of black cities. The film noir camera roved an urban underworld of jazz clubs, Turkish baths, and Chinatowns, focusing upon citified whites who flaunt their transgression of racial and sexual boundaries, their faces and bodies cast deep in shadows that signaled the blackness of their souls. As white flight began in cities across the nation during the mid-1940s, film noir provided the "white flight" generation with the lurid portrait of an urban past it simultaneously scorned and missed.

From Long Island to Los Angeles, Americans were fleeing the cities, spurred by New Deal policies that made suburban homeownership a real possibility for millions of working-class and middle-class families. With mass suburbanization came the opportunity to restore "normalcy" to American society, a vague ideal that found precise expression in American culture of the 1950s. Film noir dramatized this imperative, exhorting white Americans to abandon the moral turpitude of black cities and to restore traditions of white patriarchy in a new suburban context. For women, this meant relinquishing wages to return to the work

of family and home. For people of color, this meant exclusion from white neighborhoods that sought to preserve racial homogeneity. Film noir fueled the moral thrust of white flight in postwar America, helping to restore traditional ideals of sameness and normalcy in 1950s suburbia.

Film noir took aim at the new mass culture that debuted within the spatial context of the modern city, indicting the movies themselves as relics of a tawdry urban past, doomed for obsolescence in a new suburban future. Take the classic *Sunset Boulevard* (1950), which dramatized the decline of the studio system. In this film directed by the German émigré Billy Wilder, Gloria Swanson, then in her fifties, plays something of her real-life self in the character of Norma Desmond: a forgotten silent film star who clings to the scraps of her youthful fame in the fraying splendor of her Hollywood mansion, "the kind that crazy movie people built in the crazy Twenties," a line voiced by William Holden, the actor who plays Joe Gillis, a young, handsome, and unemployed screenwriter who entertains Desmond's delusions of stardom in exchange for her largesse. When Gillis admits his affair with a younger woman, Desmond fires a bullet into his back, murmuring, "no one leaves a star," leaving him dead in her swimming pool.

Sunset Boulevard is more than a character study of fame and its tragic consequences; it is also a parable about the end of Hollywood's golden age. The Cold War brought notoriety to Hollywood as the film industry became a conspicuous target for the witch-hunting efforts of the House Un-American Activities Committee (HUAC) and its well-publicized investigations of communist subversion. Studio executives aided HUAC's work by amassing secret blacklists of suspected communists within their ranks. The "Hollywood Ten," the ten screenwriters and directors imprisoned for refusing to answer HUAC's questions about their affiliations with the Communist Party, served to symbolize the extremes to which proponents of red baiting, aided and abetted by

corporate executives and members of Congress, would go. At this time, Hollywood utilized new filmmaking technologies such as CinemaScope and Panavision to deliver a slew of wide-screen science fiction films that depicted alien invasions with spectacular realism. Icons of destruction such as the Martians of *War of the Worlds* (1953), the giant ants of *Them!* (1954), and the fleshy pods of *Invasion of the Body Snatchers* (1956) became powerful symbols through which Americans imagined their nation's precarious fate as a new global superpower.

Film studios utilized these new film technologies to bolster revenues at the box office, which had fallen into steep decline in 1948. That year, the Supreme Court issued an antitrust ruling in *United States v. Paramount Pictures Inc. et al.*, forcing the Big Eight studios to relinquish their monopoly over the distribution and exhibition of motion pictures. This ruling inaugurated a prolonged decline in studio profits that lasted well into the 1960s. Meanwhile, white flight sealed the fate of the movie palace that once anchored a bustling nightlife. Its closing accompanied the general abandonment of downtown commercial districts across the nation in the 1950s and 1960s. From afar, a new suburban generation saw these gaudy structures as something that used to be big. But even in its decline, the shuttered movie palace seemed to echo the defiant words of Norma Desmond in *Sunset Boulevard*: "I am big, it's the pictures that got small!"

Indeed, the pictures did get small during the postwar period—very small. Television fit squarely within the new suburban culture of postwar America. As it soared in popularity in the early 1950s, it brought mass entertainment to the privacy of the home. The number of television sets rose from 6,000 in 1946 to some 12 million by 1951. By 1955, television found its place in half of all U.S. homes. The medium enjoyed a golden age during the 1950s. Although its early format drew heavily upon radio content, television soon developed its own original programming, pioneered by the commercial broadcast networks, the National

Broadcasting Company (NBC), the American Broadcasting Company (ABC), and the Columbia Broadcasting System (CBS), which dominated television broadcasting by the early 1950s. These three networks vied for top advertising dollars, which flowed according to new methods for gauging audience viewership. The Nielsen rating system, which initially provided radio market analysis during the 1920s and 1930s, perfected a unique measurement system by the late 1940s to determine audience size and thus the composition of television programming.

Television broadcasters relied heavily upon advertising revenue from corporate sponsors eager to cash in on the suburban boom. General Electric, RCA, Westinghouse, Betty Crocker, Clorox, Whirlpool, Avon, Chevrolet, and Proctor and Gamble all became household names for an expanding generation of Americans eager to consume a new suburban lifestyle pictured on TV and in magazines like *Life*, *Look*, and *House Beautiful*. The white nuclear family dominated this new media landscape. By the end of the 1950s, suburban family sitcoms like *The Adventures of Ozzie and Harriet*, *Father Knows Best*, *The Donna Reed Show*, and *Leave It to Beaver* scored high Nielsen ratings, delivering compelling, and often hilarious, idealizations of white middle-class suburban family life. The imagery of many of these programs evoked the nineteenth-century cult of domesticity: fathers went to work, mothers wore aprons, sons threw footballs, and girls played with dolls.

Most advertising and programming encouraged conformity and normalcy, but early television also demonstrated its potential to foster critical thinking and societal awareness. News reporters like Edward R. Murrow and Eric Severeid, for example, pioneered a hard-hitting brand of investigative journalism that elevated public debate, particularly with respect to the witch-hunting tactics of Senator Joseph McCarthy that inflamed the Red Scare. Utilizing the new platform of television news programs like *See it Now*, Murrow broadened his critique of anti-communist hysteria. Other programs opened new possibilities for critical social introspection

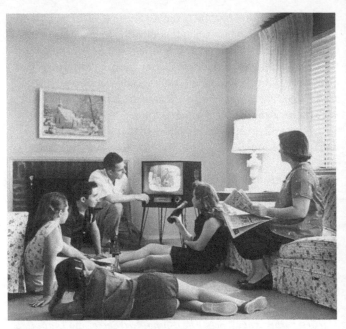

6. Between 1948 and 1955, nearly two-thirds of all American families bought a television set. While Americans debated the impact of television upon society, they made television the centerpiece of a new suburban culture that enshrined the white nuclear family.

as well. Rod Serling's *The Twilight Zone*, for example, explored the underlying tensions of postwar American society through a series of half-hour dramas that ran on CBS between 1959 and 1964. Its episodes often tackled pressing social issues—nuclear catastrophe, war trauma, communist subversion, automation, space exploration, racism, mass conformity, urban renewal—usually coded within the narrative devices of science fiction, fantasy, and horror.

Following media scholar Marshall McLuhan's dictum that "the medium is the message," the focus shifts from the content of television programming to the experience of watching television itself. In concert with the general retreat from public life in

postwar America, television sponsored the privatization of cultural experience. At the height of the Cold War, in the shadow of the nuclear bomb, television promoted an ideal of domestic containment, shaping an inward cultural focus upon the home as a sanctuary for mass consumption and traditional gender roles. It emerged as the centerpiece of a new suburban culture that provided a safer alternative to the bustle of the city and to the new mass culture that reigned at the height of industrial urbanism. By the early 1950s, a "new" new mass culture had emerged, packaged within regimented suburban spaces and built according to new architectural imperatives that maximized security, privacy, and consumer convenience.

This transition redefined the experience of spectator sports, for example. When the Dodgers moved from Brooklyn to Los Angeles in 1957, they not only brought the first racially integrated baseball team to Southern California, they also brought baseball within the emerging realm of "family entertainment." Brooklyn's Ebbets Field, like its counterparts in Chicago, Boston, Detroit, and elsewhere, belonged to the film noir city. A brick-and-mortar structure built in the late nineteenth century with no parking facilities and a seating capacity of 35,000, the ballpark suffered declining patronage as black and Puerto Rican newcomers displaced the white working-class ethnics who were the first Dodgers fans.

In Los Angeles, by contrast, Dodger Stadium was a concrete, cantilevered structure built for 56,000 spectators, surrounded by a vast parking lot that welcomed suburban commuters still willing to venture downtown if it meant safe and convenient access. City officials licensed the construction of Dodger Stadium as a form of slum clearance, evicting an established Mexican American community to build what the *Los Angeles Times* called in 1962 "the most modern baseball temple in the world." The Dodgers thus enacted their own form of white flight, eradicating the vestiges of the film noir city to "clean up" baseball from the raucous pastime

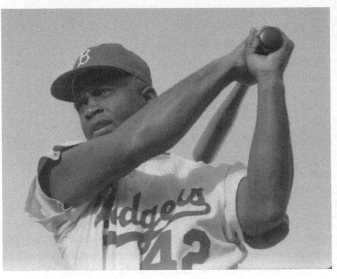

7. Jackie Robinson joined the Brooklyn Dodgers in 1947, breaking
the color line for black athletes in professional sports and heralding
a broader shift toward racial integration. The Dodgers moved to Los
Angeles in 1957.

of white working-class men to a respectable outing appropriate
for white suburban families.

As an enclosed space enshrouded by a vast parking lot, Dodger
Stadium shared architectural affinities with the shopping mall,
another master-planned environment that insulated consumers
from the city's bustle. The shopping mall debuted in the late 1940s
in suburban locales and, like Dodger Stadium, was often built at
the intersection of newly built freeways. Whereas the downtown
department store of the late nineteenth century sanctioned the
heterogeneous mixing of diverse city people, the suburban shopping
mall introduced new levels of spatial differentiation and market
segmentation, targeting the spending power of suburban women
and families. Whether Los Angeles's Lakewood Center, New Jersey's
Paramus Mall, or countless others in between, the shopping mall

provided a full array of goods and services while creating a safe refuge from what one prominent mall architect decried as the "ugliness and anarchy" of traditional downtown shopping districts.

The shopping mall arrived alongside the theme park, which first enthralled Americans with the opening of Disneyland in Orange County, California, in 1955. After his labor troubles in the early 1940s, Walt Disney ventured into television programming and then undertook a new experiment in mass entertainment. Disdainful of amusement parks like Coney Island, which shared the slumping fate of the movie palace, Disney opened Disneyland in Anaheim, some fifty-five miles south of downtown Los Angeles. Like the amusement park, Disneyland featured mechanical rides, but gone was the "hootchy-cootchy" atmosphere. Instead, Disneyland proffered "family entertainment," a set of attractions organized within five discrete themed areas that guided the park's layout and design. "Frontierland" glorified westward expansion and frontier settlement; while "Tomorrowland" celebrated American technology and material progress. "Adventureland" simulated the exotic jungles of Asia and Africa; "Fantasyland" drew upon the imagery of Disney's most popular films; and "Main Street, U.S.A.," an outdoor pedestrian mall posing as a small Midwestern town of 1900, welcomed visitors as they entered the park. Virtually all attractions, shops, and restaurants bore corporate brand names, reinforcing the park's relationship to an expansive consumer culture.

Through architectural pastiche, meticulous landscaping, and maximum corporate sponsorship, Disneyland marked a milestone in postwar American culture, a monument to Walt Disney's idealization of American culture and history. Its novel brand of entertainment saluted the white nuclear family and accentuated themes of racial difference. Aunt Jemima's Pancake House, for example, was one of the first restaurants to open at Disneyland. Sponsored by Quaker Oats (owner of Aunt Jemima pancake mix and syrup), the restaurant was housed in a building with the façade of a Southern plantation house and featured an African

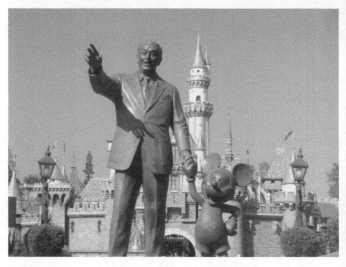

8. A copper statue of the cartoon character Mickey Mouse and his creator, Walt Disney, welcomes visitors to Disneyland in California.

American "hostess" playing the role of Aunt Jemima herself. Frontierland showcased "authentic" Indians who staged traditional dances at regular intervals, and Adventureland's Jungle Cruise displayed mechanical natives who rattled spears at passengers cruising by on boats running along an underwater track. Whiteness, patriarchy, nationalism, nostalgia, and consumption: these are the deeper themes that underlie the Disneyland experience, the very values codified by the explosive growth of white suburbia.

The New Right emerged in postwar America, defending a traditional way of life that it saw as under threat from communists, feminists, hippies, and racial justice activists. This insurgent political force, with strong ties to the military and defense production, remade the face of the Republican Party in the 1950s and 1960s, electing new leaders like Richard Nixon, Ronald Reagan, and Barry Goldwater. These men found their base in the Sunbelt, from Atlanta to Phoenix to Orange County, California.

Elsewhere, in the fast-growing suburbs of Minneapolis, Detroit, Chicago, St. Louis, Baltimore, Boston, New York, and Philadelphia, a generation of white ethnic Americans severed their historical ties to the Democratic Party, embracing a new Republican platform of small government, self-reliance, strong defense, law and order, and white privilege. In their flight to the suburbs, they rejected the old urban coalitions of the New Deal and embraced a privatized suburban culture built around an idealization of the white nuclear family.

By fueling the mass exodus to the suburbs, the automobile nurtured the development of this new political culture. It also sparked a new consumer craze. Cars enthralled postwar Americans, stoking their deep-seated faith in material progress and limitless resources. Undergirded by heavy advertising, a full-blown car culture emerged in the 1950s, showcasing bigger, faster cars adorned with chrome grills and tail fins that evoked fantasies of speed and space travel. At this time, the Buick LeSabre, the Oldsmobile Cutlass, and the Cadillac Coup de Ville became icons of American technology and prosperity, objects through which Americans pursued their long-held infatuation with status, mobility, and speed.

The automobile spurred legions of car enthusiasts across the nation to organize car clubs, car races, and auto shows. They read new magazines like *Sports Cars Illustrated* (1955, renamed *Car and Driver* in 1961), *Autoweek*, and *Car Craft*, the last founded in 1953 with a special focus on hot rodding and drag racing. Self-made mechanics invented the art of car customization, forming new subcultures, mostly within working-class communities, disassembling and reassembling automobiles to turn standardized, mass-produced commodities into high-performance and highly stylized machines. Beginning in the 1950s, a new low-rider aesthetic took shape in the Chicano barrios of Los Angeles. Low-riders sported custom-painted automobiles, often with wire-spoked wheels, whitewall tires, and hydraulic

jacks that allowed the driver to raise or lower the vehicle with the flip of a switch. The low-riders' motto "low and slow" described their penchant for cruising the wide boulevards of East Los Angeles to showcase a custom design before sidewalk onlookers and to snub the rush of modern suburban life.

Automobiles also enabled a new "drive-in" culture that emerged around gas stations, car washes, and parking lots, and they helped to bring fast food into the diet of mainstream America. Although restaurant chains like White Castle, A&W Root Beer, and Howard Johnson's had catered to roadside appetites as far back as the 1920s and 1930s, the opening of McDonald's in suburban Southern California in 1948 revolutionized food consumption by introducing streamlined production methods that sold "on the go" food products individually wrapped in disposable cartons and bags. With its promise of clean, drive-in food service, McDonald's became the template for a slew of fast food companies that catered to growing demands for fast, affordable, and convenient consumption.

Much of the car culture of the 1950s had its origins in Detroit, which, with the big three car manufacturers—General Motors, Ford, and Chrysler—had long been dubbed the nation's Motor City. Detroit enjoyed this status through the 1960s, even as auto manufacturing began shifting to suburban locales (and eventually overseas) by the late 1950s. Still, Detroit remained an industrial powerhouse, renowned not just for the sleek cars that rolled out of its factories, but also for the pop music that dominated the nation's airwaves by the early 1960s. Motown Records, founded by Berry Gordy in 1959, brought pop sensibilities to black musical traditions like gospel and rhythm and blues, creating a new sound that won mainstream appeal. Short for "Motor Town" in local parlance, Motown music made such R&B singers as Smokey Robinson, Marvin Gaye, and Martha Reeves the first "crossover" artists to breach the color line. While urban renewal, highway construction, and deindustrialization ravaged Detroit's cohesive black neighborhoods, Motown produced radio hits the way Ford

and GM produced automobiles, appropriating industrial technologies of mass production to popularize black music on an unprecedented scale.

Motown music was made for the automobile, just like Las Vegas, which bloomed in the Nevada desert after World War II as a new capital of leisure and entertainment. Once a dusty outpost along a rail line between Los Angeles and Salt Lake City, Las Vegas rose to prominence in the wake of the federal government's construction of Hoover Dam in the 1930s, which brought male workers to the area, spurring demands for gambling and showgirl entertainment. When the Nevada legislature legalized gambling in 1931, Las Vegas quickly attracted investors, a peculiar combination of Mormon elders, Teamsters members, and mob bosses from Los Angeles and New York. Their collaborations produced a new brand of gambling entertainment, organized around an automobile strip of sprawling, lavish hotels that featured expansive casinos, celebrity entertainment, and sumptuous buffets. The Dunes, The Flamingo, Caesars Palace, and the Stardust deployed, like Disneyland, a hodgepodge of competing design themes mined from nature and history. With blazing neon signs that ran several stories high, the Las Vegas Strip marked the most spectacular example of a car-oriented "strip" culture focused on the commercial pursuit of pleasure, distraction, and fun.

Even artists and intellectuals stepped beyond their lofty perch in universities and museums to explore these new western landscapes. They drove the strips of Las Vegas and Los Angeles, drawing aesthetic inspiration from gas stations and car washes and, most of all, from the imposing signs that announced their presence. Pop art emerged during the mid-1960s as a style that embraced the consumer society and its distinctive look. In New York, the work of Andy Warhol and Roy Lichtenstein mimicked the bold iconography of comic strips and advertisements, while Los Angeles artists such as Ed Ruscha and David Hockney brought the commercial icons of the vernacular landscape into the

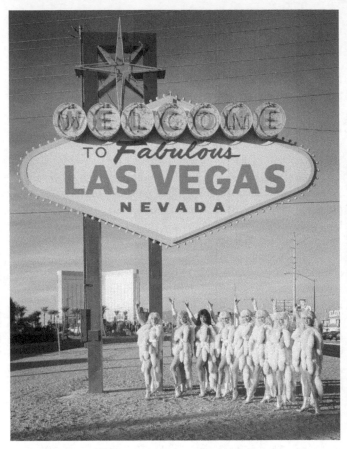

9. City of Signs: by the late 1950s, the city of Las Vegas heralded a new strip culture built around the automobile, with ordinary buildings that communicated extraordinary themes through elaborate signs and decoration.

representational tradition of canvas painting. Similarly, architects and urban planners from prestigious universities like Yale, MIT, and UCLA got into the act, teaching their students to "Learn from Las Vegas"—to discover urbanism from below: cities designed not

by the canonic wisdom of enlightened professionals, but rather by the dictates of popular taste and commercial success.

The pop sensibility, in art or architecture, was ambiguous in its relationship to the hyper-consumer society of postwar America. On the one hand, pop artists like Warhol or Ruscha found beauty in the arresting iconography of postwar consumer culture, yet, at the same time, they displayed a cool, ironic detachment from this superficial world, most apparent against the expansive white walls of galleries in New York and L.A. Less ambiguously, however, a postwar generation of public intellectuals warned about the consequences of the "affluent society." This was the name of John Kenneth Galbraith's 1958 bestseller, which argued that Americans were prone to surrender to false desires created by corporations to bolster profits. Other astute observers fueled such skepticism. C. Wright Mills predicted extreme concentrations of political, economic, and military power in *The Power Elite*, and William Whyte, in *The Organization Man*, warned about the loss of individualism in a society dominated by private corporations and public bureaucracies.

Another powerful critique of the postwar consumer society emphasized the cost for women. At a time that celebrated stereotypes of women as either sex objects (Marilyn Monroe) or submissive housewives (June Cleaver), Betty Friedan's *The Feminine Mystique* deplored the confinement of women within both suburban space and popular culture. Friedan singled out the home as a "trap" for women, living in suburbs, "the ugly and endless sprawls which are becoming a national problem." In Friedan's view, mass suburbanization stifled women's creative autonomy and forced them into lives of dependence and conformity. Though her critique focused narrowly upon the predicament of educated, white, middle-class women, it nonetheless prompted many women to question their role in the expanding consumer society of postwar America.

Such best-selling arguments, sold as mass market nonfiction, defied 1950s conventional wisdom. This term, invoked by Galbraith to describe the shared assumptions in society, found powerful expression in the words of Richard Nixon in his 1959 "kitchen debate" with Soviet premier Nikita Khrushchev. Standing in the state-of-the-art kitchen of a ranch-style suburban home built for the 1959 American National Exhibition in Moscow, the two leaders squared off before live television cameras, debating the virtues of capitalism versus communism. The premier dismissed the dishwasher and electric range as wasteful gadgets designed for immediate obsolescence, while Nixon praised these objects as examples of American ingenuity and freedom, stressing how they liberated women from household drudgery to fulfill their "natural" duties as mothers and homemakers. Such arguments won national approval for Nixon, who, in so doing, tied consumption to American ideals of freedom and prosperity.

That a detached, single-family home—not an apartment or a row house—served as the set piece of this debate illustrates how the suburban way of life shaped the nation's image of itself. Yet while mature cities like New York suffered a depletion of wealth and population during the 1950s and 1960s, they nonetheless sustained the cultural vitality and diversity that sparked a sharp defense of the city. For example, Jane Jacobs, the journalist and community activist, excoriated the rush to the suburbs and defended the virtues of old urban neighborhoods. From her stoop in Greenwich Village, Jacobs observed the social rhythms of streets and sidewalks and approved the city's "diversity and messy vitality." Her 1961 bestseller, *The Death and Life of Great American Cities*, prompted a national debate about the fate of urban life and forced Americans to rethink their ties to the city.

New York City, hell on earth in the suburban narrative of American history, flourished during the postwar period. Its advertising, television, radio, and publishing industries expanded after World War II, while its art, theater, music, and fashion

communities created new images, sounds, and ideas that shaped the broader culture. This was the New York of composer John Cage, choreographer Merce Cunningham, and artist Robert Rauschenberg, pioneers in a new avant-garde scene that experimented with the arts, breaking the conventions of aesthetic experience and performance. Modern jazz debuted about the same time in New York City, launching the age of "bebop," a new jazz style pioneered by younger musicians who abandoned the big bands of the 1930s and 1940s, forming quartets or quintets that delivered a more complex sound, one that was not danceable and demanded close listening. Bebop's faster tempos and asymmetrical phrasing featured improvisational solos, usually held together by underlying harmonies driven by percussion. The nightclubs of New York's 52nd Street were the incubators of this new sound, introducing the likes of Charlie Parker, Dizzy Gillespie, Thelonious Monk, and Dexter Gordon, jazz musicians who shirked their accepted role as entertainers to practice a serious musical form.

They belonged to an underground scene thriving within the dingy urban spaces featured in film noir. They did not enjoy the sunshine or spotlight of Disneyland, but they nonetheless asserted an alternative set of perspectives and experiences manifest in the after-hours haze of clubs, bars, and cafés. In New York, San Francisco, and Los Angeles, for example, rebellious communities of novelists and poets took shape, rejecting literary rules and genres and flouting social convention. The Beats, as they were known, criticized their conformist consumer society, fashioning an alternative vision of postwar America inspired by such disparate influences as jazz, romanticism, surrealism, and mind-altering drugs, including alcohol, marijuana, and peyote. In his controversial poem "Howl," Allen Ginsberg condemned the "Robot apartments! Invincible suburbs! Skeleton treasures! Blind capitals! Demonic industries!" of postwar America. His friend Jack Kerouac penned *On the Road* (1956), a free-form novel about a cross-country road trip and a young man's freedom from societal expectations.

While the Beats expressed a selective affinity with African American culture, contemporary black writers undertook a penetrating look at black life in the city. In *If He Hollers Let Him Go* (1945), Chester Himes explored the wartime intersections of race and class and the significance of communism to the black struggle for freedom. In New York, political essayist and journalist Ralph Ellison wrote his magnum opus, *Invisible Man* (1950), a novel about white ignorance of black humanity. The work of these and other writers gave literary expression to the civil rights movement, illuminating the cruel contradictions of being black and American. Their stories amplified demands for social justice, as did photographs circulated in national magazines. The images were haunting, including that of fifteen-year old Elizabeth Eckford harassed by a hostile mob of white students while trying to go to school in Little Rock, Arkansas, in 1957, or the mother of Emmett Till, stoically looking upon the open casket of her fourteen-year-old-son, who was brutally murdered by two white men on a family visit in Mississippi in 1955. These photographs brought the civil rights movement into the homes of millions of Americans, in black and white, for blacks and whites, forcing the entire nation to own its ugly history of white supremacy. They also sent a message to the entire world, a powerful reminder that the United States had yet to fully confront its original sin of slavery and its lasting consequences.

Other aspects of black culture inflamed the youthful passions of postwar Americans. Rock and roll exploded as a rebellious new sound in the 1950s and flourished in the following decades with the introduction of the electric guitar. Its roots lay in rhythm and blues, enthralling young audiences, black and white, when white disc jockeys and record producers realized the crossover appeal of such black artists as Chuck Berry, Ray Charles, Little Richard, and Bo Diddley. Their "race music," as it was called in the music industry, proved popular among a surging youth market and inspired a new generation of white performers. In the United States, performers such as Bill Haley and Elvis Presley were joined by those from England, the Beatles and Rolling Stones, who

launched a "British invasion" of American airwaves, to sell records and pack concert venues with hysterical teenage girls. These talented singers and musicians did not invent rock and roll, but they masterfully imitated a new sound created by black artists who had revolutionized American popular music.

Native Americans also made substantive contributions to the new rock sound. The guitarist Link Wray, a Shawnee Indian, pioneered the use of distortion, feedback, and the power chord, a sound featured in the 1958 hit song "Rumble," a tune that was banned by mainstream disc jockeys—not for its lyrics but rather for its sound. Jimi Hendrix, one of only a few black rock stars during the postwar period, was part Cherokee Indian, and he often appeared on stage in beaded jackets and moccasins.

With its diverse cultural influences, rock and roll contributed to the invention of the teenager in postwar America. This cultural construct, largely a stereotype, took shape according to the demographics of the time: the soaring birth rates between 1946 and 1964 signaled to advertising and media executives the potential of a surging youth market, mobilized through an array of consumer goods. Magazines like *Seventeen*, which debuted in 1944, and advice books like Edith Heal's *The Teen-Age Manual: A Guide to Popularity and Success* (1948), modeled adult idealizations of American youth. By the mid-1950s, however, young Americans started paying less attention to these materials and began pushing the boundaries of middle-class convention. "It's the kids telling us, instead of us telling them," reported the editors of *Ladies Home Journal* from interviews with high school students in 1951. Radio dee-jays played "race music" that catered to a lucrative youth market, while actors such as Marlon Brando and James Dean symbolized a new spirit of rebellion in young America, a hint of the counterculture to come.

These actors, like black rockers and their white imitators, however, did not end the nation's infatuation with youthful

innocence; it was the Vietnam War that did. Fought mostly by working-class, impoverished youth (the average age of U.S. soldiers in the war was nineteen, compared to twenty-six in World War II), the Vietnam War radicalized American youth, especially college students who identified with the New Left, a shift away from the "old left" labor politics of the 1930s and 1940s and toward a new inclusive vision of social justice that allied with identity-based causes like the civil rights and feminist movements, and one that targeted not just political institutions, but also interpersonal relations and popular culture. On college campuses throughout the nation, students embraced this new model of political activism through organizations like the Students for a Democratic Society (SDS), which advocated participatory democracy and demanded free speech in higher education. SDS organized many antiwar demonstrations, including a march of twenty-five thousand students in Washington, DC, in 1965, the first of many large-scale protests against the war. Antiwar movements were part of a burgeoning youth culture in 1960s America that rallied around a new identity politics, one that included blacks, Native Americans, Chicanos, Asian Americans, women, and homosexuals together with a hippie counterculture that embraced sexual experimentation, communal living, and altered states of consciousness induced through marijuana and LSD. Through music, dress (or lack thereof), language, and other cultural signifiers, these social movements inserted new voices and perspectives into the fabric of American culture.

Chapter 6
The world wide web of American culture

The revolution began off Broadway. On October 17, 1967, Joe Papp's Public Theater in New York City opened with a new form of musical theater. *Hair: The American Tribal Love-Rock Musical* electrified audiences with a theatrical celebration of the counterculture and its way of life: nudity, drug use, profanity, draft dodging, and lots of hair—blonde, black, straight, curly, kinky, and long. A story about the bohemian lives of a group of hippies in New York City, *Hair* broke ground with a multiracial "tribe" of performers and songs that spoke to the times: "Colored Spade" addressed racial issues, "Sodomy" celebrated free and open sexuality, "Aquarius" reflected a contemporary interest in the zodiac, and "Three-Five-Zero-Zero" evoked antiwar sentiment with incendiary lines like "prisoners in niggertown/it's a dirty little war." *Hair* generated much controversy for breaking with the vanilla conventions of 1950s Broadway fare like *Oklahoma!*, *Carousel*, and *My Fair Lady*, and it anticipated the success of new rock musicals in the 1970s like *Jesus Christ Superstar*, *Godspell*, *The Rocky Horror Picture Show*, and *Grease*. After its Broadway run of 1,750 performances, *Hair* toured the nation, sparking protest in some Midwestern cities, and going global, with "tribes" assembled in over twenty nations to dramatize the hippie lifestyle around the world.

The 1960s brought new stories from the margins into the mainstream of American culture, not just onto the Broadway

stage, but into the mass media as well, and other artistic venues—
some borrowed from European traditions, such as photography,
film, and painting, others rooted in non-Western societies,
including dance, music, and muralism. Minority social groups also
wanted their stories known in the academy. As college students,
they demanded inclusion through the establishment of gender
and ethnic studies programs on campus, places that welcomed
their stories, which had been excluded from Eurocentric
disciplines. Their efforts fueled a "cultural turn" in the humanities
and social sciences, heightening skepticism toward ideals of
objective science and renewing interest in the subjective
expressions of language, narrative, and representation. They met
fierce resistance from the defenders of the Enlightenment and its
canons of "great art" and "great literature," its taxonomy of nature
and society, and its orthodox methods of scientific inquiry.
Nonetheless, women, racial minorities, and homosexuals pressed
forward, voicing their presence not just in the ivory tower, but also
in new frontiers of mass communication.

The black civil rights movement gathered steam in the 1950s and
inspired more stringent forms of black activism in the 1960s.
By the mid-1960s, the Black Power movement took shape amidst
urban uprisings in black neighborhoods that bore the brunt of
poverty and segregation. While it brought national attention to
black demands for equality, it also ushered in a new era of identity
politics. With struggle and perseverance, these movements found
powerful channels of influence, in the halls of government and on
the streets of community activism, but they also inspired new
forms of art, literature, poetry, film, video, and photography. This
cultural work was not ancillary to the "real" politics of community
activism and organizing; rather, it was integral to the struggle
itself. The Black Arts movement, for example, took root in Harlem
in the late 1960s and early 1970s, launching the careers of
novelists and poets such as Toni Morrison, Maya Angelou, Amiri
Baraka, and Ishmael Reed. Their work promoted ideals of
community self-empowerment and cultural sovereignty, and they

influenced black artists and writers in other cities who dedicated their work to black empowerment.

In the Southwest, Mexican Americans also linked art to activism. Battered in their communities by invasive highway construction and urban renewal projects, Chicanos in urban barrios organized their own "Brown Power" movement, which invoked racial pride through the concept of *la raza* ("the race"). The movement included the Brown Berets, a paramilitary organization of young men who embraced an edgy style that resembled the look of the Black Panthers, who packed weapons and wore black berets and sleek leather jackets. Chicano artists launched murals programs in their neighborhoods, depicting scenes of Chicano history and identity on the walls of local buildings. With a didactic emphasis upon self-representation and self-empowerment, muralism deliberately invoked Mesoamerican aesthetic traditions.
The Chicano movement also included the labor struggles of farmworkers, and creative performance played a critical role. In conjunction with the United Farmworkers movement and the organizing efforts of Cesar Chavez, in 1965 the playwright Luis Valdez, a child of migrant farmworkers, established *Teatro Campesino*, a theatrical troupe formed by farmworkers for farmworkers, rendering the struggle for workers' rights with music, wit, and satire in California's heartland.

Few aspects of American culture during the 1960s were untouched by the spirit of protest. Politics injected itself in a big way even in sports. While spectator sports had always served as testing grounds for ingrained assumptions about the biological superiority of white men over everyone else (think here of Jack Johnson's victory over white boxer James J. Jefferies in 1910, or the Brooklyn Dodgers signing UCLA graduate Jackie Robinson in 1947, breaking the color line in professional sports), the sixties introduced a new generation of sports icons who served identity politics with a walloping punch, or a raised fist. Black sprinters Tommie Smith and John Carlos, for example, won gold and

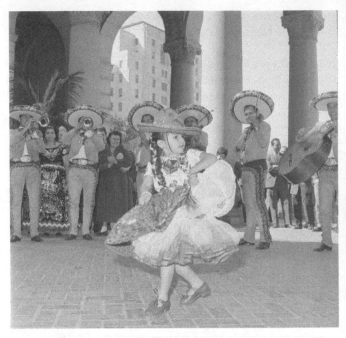

10. A girl dances to a mariachi band performing in the rotunda of the Los Angeles City Hall. A folk music and dance tradition from Mexico, mariachis are part of Mexican American popular culture in the United States as well.

bronze, respectively, at the 1968 Olympics in Mexico City. At the medal presentation, during the rendition of the "Star Spangled Banner," the two athletes sparked controversy by assuming the provocative gesture of the Black Power salute on the awards podium. Cassius Clay, arguably the greatest boxer in American history, became a countercultural icon when he denounced the Vietnam War, embracing Islam and changing his name to Muhammad Ali.

Even in genteel sports like tennis, blacks and women were breaking barriers. Arthur Ashe, a child of the Jim Crow South and another UCLA graduate, was the first African American man to

win the U.S. Open title in tennis in 1968, a momentous event in a sport sponsored by elite universities and exclusive country clubs. Unlike football, baseball, and basketball, tennis also had a women's game. Billie Jean King won nine grand slam titles in tennis between 1966 and 1972, but perhaps her most famous victory came the following year, when she accepted a challenge from tennis legend Bobby Riggs in the "Battle of the Sexes," a mass media event that pitted a twenty-nine-year-old woman in her tennis prime against a fifty-five-year-old male former champion who billed himself as the "number one male chauvinist in the world." Some 30,000 spectators attended this event at the Houston Astrodome, and it aired live on ABC before 50 million viewers in the United States and 90 million worldwide.

King's victory over Riggs (6-4, 6-3, 6-3) affirmed gender equality on live television, and it arrived amidst the thrust of feminism's "second wave," which also inspired unique forms of artistic expression. After 1965, as more young women began advocating for an all-out gender revolution, women of diverse racial, ethnic, and class backgrounds mobilized the arts to render the feminist cause. In 1971, pioneers of woman-centered art Miriam Schapiro and Judy Chicago founded "Womanhouse" in Los Angeles, an art collective established as "a new art community built from the lives, feelings and needs of women."

Betty Saar, affiliated with the Black Arts movement, created such provocative assemblages as *The Liberation of Aunt Jemima* (1972), which depicted an Aunt Jemima doll holding a broom in one hand and a shotgun in the other, while Judith Baca spearheaded a feminist muralist movement in the Chicano community in Los Angeles. The 1980s introduced a new generation of feminist artists, among them Barbara Kruger, who drew attention for her explorations of power and sexuality through multimedia installations. New York photographer Cindy Sherman, similarly, explored the iconography of women by posing before her own camera as different characters. These artists

earned critical acclaim for their work and for inserting a woman's perspective into an artistic canon made by and for men.

Feminism also reoriented television programming with new shows that dramatized the lives of urban career women, often with humor and compassion. *The Mary Tyler Moore Show* ran on CBS from 1970 to 1977, starring dancer, actor, producer, and fashion icon Moore, who played Mary Richards, a writer in a Minneapolis television newsroom. Set in the upper Midwest, Moore portrayed a hard-working and successful single woman who took the pill, kept a close circle of girlfriends, and challenged the sexism of male colleagues. The show's success inspired a slew of prime-time sitcoms about strong, independent women. *Maude* starred Bea Arthur as a feminist matriarch in a suburban New York setting; *Alice* depicted a single mother working as a waitress in Phoenix, Arizona, and *One Day at a Time* portrayed the daily struggles of a divorced Indianapolis mother and her two teenage daughters. These programs constituted a seventies version of feminist TV, depicting many of the same concerns that second-wave feminists brought to the fore of public discourse.

Television also "discovered" black America in the 1970s, adapting stories about their diverse experiences for mass entertainment. Sitcoms such as *Sanford and Son, Good Times*, and *What's Happening?* packaged black wit and humor within the conventions of prime-time programming, usually garnering critical acclaim and high Nielsen ratings. Other sitcoms, such as *The Jeffersons*, depicted a black nouveau riche couple on New York's Upper East Side, a departure from TV's typical focus upon black people in salvage yards and public housing. Their high ratings indicated their cross-racial appeal, as did the ABC mini-series *Roots* (1977), which, in seven episodes, told the story of an African American family across seven generations, based upon the 1976 novel by Alex Haley, which won a Pulitzer Prize and was published in some thirty-seven languages. Drawing in 85 percent of television viewers for its series finale, *Roots* captivated

white Americans with a saga about the black struggle from slavery to freedom.

The Jeffersons and *Maude* were spinoffs of CBS's *All in the Family* (1971–1978), produced by Norman Lear and initially declined by ABC for being too controversial. Set in a blue-collar neighborhood of Queens, *All in the Family* focused upon the domestic lives of Archie and Edith Bunker, their daughter, and her husband. The show tackled a wide variety of social issues—bigotry, homosexuality, sexism, protest, menopause, vasectomy, abortion, and miscarriage. Departing from television's traditional focus on middle-class professionals, Archie Bunker gave an unvarnished portrait of the white working class. His bigoted views toward "coloreds," "jungle bunnies," "kikes," "spics," "fags," and his own "dumb Polack" son-in-law sparked much controversy and some compassion for an aging white America struggling to adapt to a rapidly changing world.

Hollywood, meanwhile, also explored the counterculture during the late sixties and early seventies. The baby boomers came of age in this moment, seeking alternatives to the materialism, hypocrisy, and conformity of bourgeois society and inspiring new films that exposed the limits of American power and prosperity. White suburban domesticity, the centerpiece of postwar American culture, was a prime target. Films such as *Who's Afraid of Virginia Woolf?* (1966), directed by Mike Nichols, who began his career in Chicago's improv comedy scene, presented a searing portrait of domestic abuse and alcoholism in a New England college town. The following year, Nichols directed *The Graduate*, which dramatized the disaffection of an aimless college graduate from the shallow suburban world of his parents.

The interracial love affair of *Guess Who's Coming to Dinner?* (1967) diagnosed the subtleties of white liberal racism. *Dr. Strangelove* satirized nuclear war madness and right-wing ideology, while *Nothing but a Man* (1964) depicted southern black life from a black point of view. Other films took aim at some of the nation's most

deeply cherished myths. Turning the conventions of the John Wayne western on its head, *Bonnie and Clyde* (1967) and *The Wild Bunch* (1969) introduced controversial levels of onscreen violence to present a counter myth of "how the West was won." *Easy Rider* (1969), hailed as a touchstone for its generation, narrates the cross-country motorcycle adventures of Wyatt and Billy, two free spirits seeking escape from mainstream America.

These films defined the "New Hollywood" as it took shape during the late 1960s, enabled by structural changes in the film industry. By the end of the decade, what remained of the old studio system had been bought up by mass-media conglomerates. Films were now put together as "deals" between agents or independent producers, who secured financial backing from the old studios, who handled distribution. Filmmakers thus had more control over their product, especially with a new ratings system that replaced the old production code in 1966. At the same time, film schools began training a younger generation of directors who were literate in film history and influenced by experimental filmmaking in France, Italy, and Japan. They produced a new crop of technically innovative and socially conscious films that reflected the climate of social change in 1960s America, introducing new cinematic techniques and political perspectives.

The New Hollywood flourished within the prosperity of 1960s America, but the political and economic turmoil of the following decade wrought a darker cinematic tone. The Vietnam War aroused intensifying opposition at home and diminished national prestige abroad. The oil embargo of 1973, imposed against the United States by the Organization of Petroleum Exporting Countries (OPEC) for its support of Israel during the 1973 Arab-Israeli War, sparked a domestic energy crisis and widespread concerns about U.S. production capacity. The Watergate scandal of 1972–74 and the resignation of President Richard Nixon brought a new crisis of leadership and legitimacy in American politics. These developments, compounded by a daily stream of

news headlines about corporate malfeasance, economic recession, rising inflation, and spiking unemployment, led to a "confidence gap" in public attitudes toward government and business and introduced a deep pessimism that brought an end to the exuberance and idealism of the post–World War II period.

The film culture of the 1970s reflected this bleak new outlook, often with a sharp rebuke to the identity politics of blacks, women, and gays. Some films took aim at institutional authority and the entrenchment of political and economic power. As American workers began to feel the sting of economic recession and deindustrialization, *One Flew Over the Cuckoo's Nest* and *All the President's Men*, two of the top-grossing films of 1976, demonstrated the broad appeal of movies that portrayed skepticism toward institutional authority. Films such as *Chinatown* (1974), *Network* (1976), *Coma* (1978), *Alien* (1979), and *The China Syndrome* (1979) directed this mistrust toward the economic establishment, exposing greed, corruption, and covert conspiracy at the heart of corporate America.

Other films, however, blamed the victim. The 1970s marked the beginning of a conservative backlash against the social upheavals of the previous decade. The dislocation of white male patriarchy, brought about by the shifting geography of economic opportunity, later known as "deindustrialization," and the surging political power of minority groups, mobilized a "silent majority" in a counterrevolutionary spirit. Enduring the scandal of Watergate and the tepid leadership of Gerald Ford and Jimmy Carter, who in 1977 identified the deep "malaise" that afflicted the nation, blue-collar America shifted its political allegiance from the Democratic Party to the Republican Party, with its promise of lower taxes, heightened national defense, and an end to a bloated welfare state that allegedly granted undue privileges to women and minorities. The election of Ronald Reagan as president in 1980 marked the crescendo, not inauguration, of a creeping conservatism in white America, foreshadowed by the cinematic culture of the 1970s.

That decade saw the return of genre films, a reaction against the experimental style of the New Hollywood and a reassertion of box-office formulas. Disaster films such as *Airport* (1970), *Earthquake* (1974), *The Towering Inferno* (1974), and *Jaws* (1975), for example, depicted natural and technological crises as metaphors through which to convey the unraveling of the liberal social order and the return of white male heroes. Horror films such as *The Exorcist* (1973) and *The Omen* (1976) conveyed a similar message through controversial portraits of misogynistic violence, while also reflecting a renewed interest in the occult and a growing skepticism toward science and technocratic rationality. An offshoot of this genre was the "slasher" films of the 1970s: *The Texas Chain Saw Massacre* (1974), *Carrie* (1976), and *Halloween* (1978), which depicted, in graphic detail, the mutilation of women's bodies, offering a conservative metaphor for the punishment that independent, outspoken women deserved. By depicting the breakdown of the nuclear family and the absence of male authority, these films registered both the conservative backlash against social movements like feminism and gay liberation and the rise of the Christian right.

The 1970s also witnessed a resurgence of "social problem" films, a genre that originated in the late 1940s and 1950s to explore issues of crime, race, drugs, and youth gangs. Initially, they reflected a liberal or leftist emphasis upon institutional reform and criminal rehabilitation, but the 1970s introduced a more conservative outlook that corresponded to rising support for the death penalty and growing opposition to affirmative action and busing in national polls. In the popular *Dirty Harry* films (1971–88), for example, Clint Eastwood played a rogue cop who sidesteps a weak criminal justice system to inflict his own brand of vigilante justice upon hippie serial killers, psychopathic women, and violent blacks. A more renowned example of the genre, *Taxi Driver* (1976) featured Robert De Niro as Travis Bickle, a Vietnam vet who works the graveyard shift driving taxis in New York City. Disgusted by the city's sleaze and dysfunction, Bickle sinks into a

114

psychopathic depression, turning to extreme physical fitness and vigilante violence to recover a sense of moral order. Bickle embodied the estrangement of straight white masculinity in a period of rising urban crime and a strong backlash against urban liberalism, anticipating public support of figures like Bernhard Goetz, a white New Yorker who shot four black muggers on a subway train in 1984 and was hailed by the tabloid media as the "subway vigilante" who enforced his own brand of law and order.

De Niro also starred in a white ethnic revival that found powerful forms of expression in the mass media. As the Italian immigrant Vito Corleone in *The Godfather II* (1974) or the Italian American boxer Jake LaMotta in *Raging Bull* (1980), De Niro joined other actors, writers, and directors who made the European immigrant experience a centerpiece of 1970s American culture. The descendants of eastern and southern European immigrants thus found prominent new roles in the culture; they could be found in Hollywood, for example, through the directorial work of Francis Ford Coppola, Woody Allen, and Martin Scorsese, or the acting of Barbra Streisand, Al Pacino, and Cher; and on television, with such frankly ethnic characters as Arthur Fonzarelli of *Happy Days* (1974–1984), Laverne DeFazio of *Laverne and Shirley* (1976–1983), and Rhoda Morgenstern of *Rhoda* (1974–1978). These characters represented a new kind of whiteness in American culture, rejecting the melting pot and adapting a new politics of group identity.

This "Roots Too" movement, adapted by Jewish, Italian, Irish, Slavic, Polish, and Ukrainian Americans, also took shape through the establishment of new political action groups, ethnic heritage programs, ethnic museums, and forms of ethnic merchandising, such as the popular T-shirts that read "Kiss Me, I'm Irish." White Americans thus reasserted their centrality in 1970s American culture, revising their history as the classic American story of assimilation and acceptance through hard-work, self-reliance, and community cohesion.

One icon of white ethnicity was John Travolta. He skyrocketed to fame with Paramount's 1977 release of *Saturday Night Fever*, a film that won critical acclaim as the story of the son of Italian immigrants, Tony Manero, who struggles to get by on his good looks and hot moves on the dance floor of a Brooklyn discothèque. The film's immense popularity had much to do with its soundtrack, which featured the disco sound that dominated radio airwaves in the mid-seventies. A new style of dance music that began in New York, disco drew upon R&B and soul music, mixing it with classical sounds of violins, pianos, and saxophones, all driven by the fast, pounding beat of bass and percussion. Instead of live musicians, disco enthroned the disc jockey, or DJ, who mixed vinyl records to pack a dance floor with a pulsing beat. Cocaine fueled this nightlife, especially at exclusive clubs like New York's Studio 54, a glittering world of sex, celebrity, and disco. The music featured the powerful vocals of Gloria Gaynor, Donna Summer, and other black women who belted out their demands for freedom, respect, and sexual pleasure.

The disco nightlife also welcomed a nascent gay community, just finding its voice in national conversations about civil rights. Disco inserted new perspectives into the mainstream of American culture, and granted new visibility to blacks, gays, and women. Its Top 40 success influenced mainstream rock bands like the Rolling Stones and Blondie, and it inspired such new television programs as *American Bandstand* and *Soul Train*, which featured dancers and live performances. Born in New York, disco went global, introducing the discothèque in Paris and drawing producers and musicians from Europe, Africa, Asia, and Latin America.

Disco also sparked a backlash. The religious right, for example, railed against the music—along with TV sitcoms, homosexuality, pornography, abortion, sex education, and divorce—for the immorality that they believed it celebrated. Rock purists condemned disco as well, denouncing its synthetic, over-produced

sound. In 1979, one Chicago radio station sponsored "Disco Demolition Night" at Comiskey Park. In between a double header between the Chicago White Sox and the Detroit Tigers, 7,000 fans rushed the playing field chanting "Disco Sucks!" as they threw disco records into a bonfire, destroying parts of the field itself. Disco found its sonic antithesis in punk, an edgy genre of rock music that featured a fast-paced, raw sound with stripped-down vocals and instrumentation. While British punk bands like The Clash and Sex Pistols condemned colonialism and the class system in angry lyrics, American bands like The Ramones and New York Dolls exalted the youthful pleasures of sex and drugs. Unlike disco, jazz, and much of rock and roll, punk subordinated the influences of black musical traditions to amplify the rage of straight young white men in American popular music.

Despite hostile Christians, punks, and rock purists, disco enjoyed an afterlife in the 1980s. British bands adopted the disco sound to produce a highly synthesized, "new romantic" or "new wave" music, which rejected the austere masculinity of punk and blended ingredients of Motown, reggae, and disco with European melodic traditions. From Britain, Roxy Music, Duran Duran, Culture Club, The Cure, and Wham! launched a "second British invasion" of the U.S. consumer market, ruling a transatlantic culture of the post-disco sound, reviving the glitzy, gender-bending styles of "glam rock" in the 1970s. In the United States, Michael Jackson, Prince, and Madonna fueled the disco nightlife even after disco died. With seven number one hits and eight Grammy Awards, including album of the year, Michael Jackson's *Thriller* (1984) became the best-selling album of all time, synthesizing elements of disco, pop, rock, and soul music. Around this time, Madonna emerged from New York's club scene with a brash sexuality, sparking controversy and boosting sales of records, cassettes, and CDs. The song "Controversy" was Prince's 1981 breakthrough hit, introducing the artist's preternatural musical talent that combined rock, soul, funk, and disco to produce a string of dance-floor hits during the 1980s, 1990s, and beyond.

The iconic stature of these pop artists depended in no small part upon the introduction of the music video, which debuted in the cultural mainstream in 1981 with the introduction of MTV (Music Television), the satellite network that featured twenty-four-hour broadcasts of music videos, short films that integrated music and video. MTV was part of a larger cable revolution in television programming. Under the leadership of Reagan appointee Mark Fowler, the Federal Communications Commission gave broadcasting companies greater freedom to determine the content and quality of television programming, and they no longer had to provide public, educational, and government access. New genre stations like CNN (twenty-four-hour news), The Discovery Channel (science programming), and QVC (marketing and sales) catered to more specialized segments of the viewing public and ended the reign of the three major broadcast networks. Marrying the experience of watching television to the practice of listening to the radio, MTV proved immensely popular, despite protests from the religious right for its frequent depictions of sex, drugs, and violence, and criticism from the music industry, which worried that the channel prized slick production over musical talent. In response, MTV began banning explicit material and putting videos such as Michael Jackson's *Thriller* into heavy rotation, proving that acclaimed music could be presented within well-produced videos, a formula for selling millions of records.

MTV also featured videos from British bands like The Vapors, whose 1980 hit "Turning Japanese" suggested the disparate global influences found in 1980s American culture. While the song invoked Western fantasies and stereotypes about Japan and "the Orient" more broadly, it also spoke to the explosion of a Japanese consumer culture that was making a global impact, especially in the United States. On the West Coast, sushi piqued the American palate, launching a new craze in *haute cuisine* that moved from west to east and challenged the hegemony of French and Italian chefs. Japanese designers like Comme des Garcons and Yohji Yamamoto dazzled the fashion crowds of Paris, London, and New

York. It was the realm of personal technology, however, in which Japanese manufacturers most directly altered the cultural lives of Americans and other global consumers. Companies such as Nintendo developed popular video games like Donkey Kong and Super Mario Bros., while Sony introduced the Walkman, a portable cassette player with headphones that enabled a private listening experience. Music on the go diminished the need for the audience by personalizing mass-produced entertainment. It conjured the individual experience of music listening on transistor radios in the 1950s and anticipated watching movies on smartphones in the 2000s, at once privatizing and globalizing American cultural life.

The crisis sparked by the human immunodeficiency virus infection, a virus believed to have originated in West Africa, and acquired immune deficiency syndrome (HIV/AIDS) marked a more sinister global influence upon American culture in the 1980s. With the first confirmed cases discovered among homosexual men in the United States in 1981, the AIDS crisis turbocharged the gay liberation movement, mobilizing artists, activists, and musicians against the federal government's seeming indifference to the mysterious deaths of tens of thousands of people, mostly urban gay men. Merging art and activism, a new generation of queer activists called attention to the crisis in provocative ways.

For example, the gay rights activist Cleve Jones established the Memorial Quilt, consisting of hundreds, and eventually tens of thousands, of quilt panels, each commemorating the individual lives lost to AIDS. Filling an entire football field, the Memorial Quilt embarked on a twenty-city tour, collecting panels along the way. Queer activist organizations, including the AIDS Coalition to Unleash Power (ACT UP) and Queer Nation, undertook savvy new media campaigns, establishing new artist collectives and new techniques of guerrilla marketing that included murals, billboards, posters, and stickers to spread messages of tolerance and acceptance. Similarly, the Red Hot Organization, formed in

1989, fought AIDS through pop culture. Its first album, *Red, Hot and Blue*, brought together some twenty recording artists to reinterpret a Cole Porter song, dedicating the proceeds of all sales to HIV/AIDS relief.

If gay white men developed new cultural strategies to fight the scourge of AIDS and homophobia, straight black men pioneered a new urban sound that called attention to the crises of poverty and violence that wracked black America. Hip-hop rose as disco declined, but it too relied upon the commanding presence of a deejay who sampled the melodies, beats, and rhythms of popular disco hits with two turntables and a microphone. By most accounts, hip hop began in the public housing projects of New York City, which hosted block parties driven by the beats of deejays who "mixed" and "scratched" vinyl records, accompanied by lyrics "rapped," not sung—more akin to poetry and spoken word—that delivered streetwise accounts of life in the ghetto.

Early hip hop, through the talents of Grandmaster Flash, Run-D.M.C., and others, found its most compelling expression not just through hard-hitting rap lyrics, but also through state-of-the-art sound systems, equipped with turntables used both as conveyers of recorded music and as musical instruments themselves, as well as sound mixers, amplifiers, and massive speakers that delivered soul-shaking bass that powered the whole affair. In Los Angeles, a "West Coast" sound developed through the talents of Dr. Dre, Snoop Dogg, Ice Cube, and others who pioneered new variants of the emerging hip hop genre, including a mellow sound that extoled the pleasures of sex, marijuana, cruising, and camaraderie, and a harder "gangsta rap" that asserted a pointed critique of a racist political economy.

Hip hop drew heavy criticism for its overtures to black nationalism, its exaltation of drugs and alcohol, and its misogyny and homophobia, and while its embrace of African and African American musical traditions accentuated its difference from the

cultural mainstream of white America, that mainstream also influenced hip hop in surprising ways. Hip hop's love of bling, for example, whether through lyrical fantasies about flashy cars, private jets, and the finest champagne, or through the gold rings and chains worn by many rap artists, reflected the atmosphere of Reagan's America, which celebrated the ostentatious display of wealth in times of rising economic inequality. First Lady Nancy Reagan mastered a stately version of White House bling, spending exorbitant sums to entertain Washington elites, Hollywood royalty, and foreign dignitaries, which the media reported on to a public struggling with rising inflation and unemployment. Lampooned as Marie Antoinette in such progressive magazines as *Mother Jones* and *The Nation*, Nancy Reagan nonetheless embodied a style emulated by television producers, who cashed in on such prime-time soap operas as *Dallas* (1978–1991), *Dynasty* (1981–1989), and *Falcon Crest* (1981–1990) that showcased intrigue and luxury among the ultrarich. These programs turned Thorstein Veblen's critique of conspicuous consumption into an ethical imperative, culminating in television shows like *Lifestyles of the Rich and Famous*, an insider's tour of elite habitats that stoked public appetite for "champagne kisses and caviar dreams." American writers took up the subject of crass materialism in 1980s America. Tama Janowitz depicted the lives of struggling artists in *Slaves of New York* (1986), Tom Wolfe satirized the greed of New York yuppies in *The Bonfire of the Vanities* (1987), and Bret Easton Ellis exposed the jaded snobbery of rich kids in Los Angeles in *Less Than Zero* (1985).

The excesses of 1980s culture—whether in art, literature, television, or music—energized far Right activists to organize against the civil rights gains of previous decades. They targeted the institutions that they believed promoted the influence of a liberal orthodoxy, especially universities and government. Critical to this effort were the arguments of Allan Bloom, a University of Chicago professor who wrote *The Closing of the American Mind* (1987). Bloom railed against the "tenured radicals" in higher

education who shunned the canonical texts of Western civilization (Plato and Shakespeare, for example) in favor of women and minority writers (Virginia Woolf and W. E. B. DuBois). This development, according to Bloom and other conservatives, introduced a dangerous relativism that hijacked traditional values and beliefs in favor of "political correctness," a term adopted by conservatives to deride efforts to promote respect for oppressed social groups through changes in language or policy. Right-wing ideologues also attacked the National Endowment for the Arts (NEA) for its support of artists whose work they considered "obscene" or "indecent." The NEA complied, rescinding its support for dozens of artists, many of whom addressed gay/lesbian and feminist themes in their work. Doing so prompted criticism that the NEA's decision was really based upon politics, not artistic merit, and it led several artists who lost funding to sue the NEA, winning an out-of-court settlement.

The "culture wars" reached a fevered pitch during the administration of President Bill Clinton, a Southerner who ended the Reagan-Bush era by becoming the first baby boomer to hold the presidency, running as a centrist Democrat who co-opted some Republican positions. Clinton and his wife, Hillary Rodham Clinton, who took an active role in White House policymaking, were nonetheless branded by the opposing party as liberals and former civil rights radicals who embodied the moral turpitude of the 1960s. Conservatives bristled when the president admitted to trying marijuana (though he claimed he did not inhale) and they lambasted the first lady for meddling in political affairs, but they found their cause célèbre during Clinton's second term, when a female intern confessed to having sexual relations with the president in the White House.

After previous efforts to prove wrongdoing by the Clintons failed, the admission by the president that he did have inappropriate contact with the intern (after initially denying such allegations) emboldened Republicans in the House of Representatives to

initiate impeachment hearings. Although this effort stalled in the Senate, the proceedings ignited a twenty-four-hour news cycle driven by new partisan cable outlets like Fox News as well as radio programs hosted by right-wing ideologues like Rush Limbaugh and Glenn Beck. Far-right ideologues took every opportunity to chastise the centrist Democrat with conservative platitudes about family values and lying under oath, but ultimately the president and first lady proved an elusive target in the culture wars, evading the foils of the Right with a slight margin of approval in national polls.

The president's personal judgment notwithstanding, the Clinton era presided over the single largest phase of economic growth in the nation's history and witnessed the beginnings of a tech boom that revolutionized American society. The technology of digitization, the conversion of objects, images, sounds, and signals into binary code (1s and 0s), had been available in the United States since the 1950s (as with the computer mainframe, introduced by IBM in 1952), but during the 1990s computing and electronics manufacturers, mass media outlets, and consumers realized the full potential of digital technology, enabling the formation of a new culture industry headquartered some forty miles south of San Francisco. Here, in "Silicon Valley," a new information-industrial complex was born, powered by scientific research at Stanford University and eventually dominated by the computer manufacturers Apple and Hewlett Packard; the search engine companies Netscape, Yahoo, and Google; and eventually the social media platforms Facebook and Twitter.

Seattle emerged as a rival center in the digital revolution, with its Microsoft empire, founded by Bill Gates, who developed the Windows operating software that has dominated the personal computer market since the early 1990s. The West Coast tech industry launched the World Wide Web, a global platform for the transmission of digital images, information, and music through satellites, personal digital devices, network browsers, computer

mainframes, and (eventually) wireless signals. Originally intended to give universal access to a universe of data, the web quickly became a virtual space with multiple uses for commercial, financial, recreational, educational, and social purposes. It radically decentralized the flow of information, enabling inexpensive and direct communication among individual users around the world.

The Internet provided an exciting world of discovery for Americans with access to computer devices, but its consequences were mixed. Initially, it spelled disaster for the recording, publishing, television, and film industries, enabling open access to copyrighted material and forcing the closing of brick-and-mortar stores that sold (or rented) records, compact discs, books, magazines, newspapers, videos, and feature films. Not unlike the massive department stores that wreaked havoc on the livelihoods of small merchants and shopkeepers at the turn of the twentieth century, online retailers, led by Amazon, have taken over the new marketplace, providing universal access to a world of consumer goods and services; however, they have done so at a cost to public life. The executives of the culture industries struggle to adapt, either by partnering with online platforms or by suing them, spending exorbitant sums to prevent copyright infringement and online piracy.

Consumers are left on the sidelines of these titanic battles, but with new digital tools, they are taking the means of cultural production into their own hands. Today's smartphones come equipped with cameras to make videos and photographs, which make for interesting postings on Facebook, Instagram, and YouTube, and they offer the opportunity to reinvent oneself for a broad online audience. In turn, they also threaten the status quo. Across the nation, police departments are now making officers wear body cameras to record public interactions that are increasingly recorded by smartphone vigilantes, onlookers who use their phones to document the potential for law enforcement abuse.

The digital revolution at the outset of the twenty-first century decentered cultural production away from media conglomerates and fostered a new plurality in American society. The 2008 election of Barack Obama as president of the United States reflected the successful mobilization of social media to elect the nation's first African American president. The Obama years celebrated the nation's history of diversity and inclusiveness and fostered interconnected and diasporic communities of "global citizens." Yet they also sparked a sharp backlash from those who reject globalization and its power to demolish traditional social distinctions like race, nation, class, and gender.

At the same time, a new "cyberwar" took shape among national and supranational powers, deploying computer technology to sabotage the work of rival states or organizations, often by attacking information systems for strategic or military purposes. Their efforts include launching attacks on political candidates as well as planting information directed at voters who seek information that confirms their political ideology. Foreign interference in national elections comes in the form of disinformation, or hacking, that is, the unauthorized use of computers to access proprietary information. The illicit trafficking of 1s and 0s reflects the weaponization of digital information in the twenty-first century, pitting nations, political parties, and nonstate organizations against each other in a global contest for domination.

Despite its futuristic form, cyberwarfare is but the latest chapter in the struggles that define American cultural history—struggles over meaning, identity, power, and resources. Early engravings of Indian peoples, Revolutionary War–era newspapers, minstrel shows, *Godey's Ladies Book*, *Uncle Tom's Cabin*, advertisements, museum exhibits and carnival displays, film, radio, *The Mary Tyler Moore Show*, hip hop: these and other expressions of culture reflect competing perspectives and points of view that rode the political currents of their time, starting riots and wars, mobilizing diverse constituencies, and empowering some social groups while

subordinating others. At the outset of the information age, the symbolic world of American culture continues to unite diverse and disparate segments of the population, even as it remains a battleground, fraught with the very tensions and conflicts that define the nation's history and identity.

References

Introduction

The Matthew Arnold quotation is from *Culture and Anarchy* (Cambridge, UK: Cambridge University Press, 1932), 6.

The Franz Boas quotation is from James W. Cook, Lawrence B. Glickman, and Michael O'Malley, *The Cultural Turn in U.S. History: Past, Present and Future* (Chicago: University of Chicago Press, 2008), 6.

"The totality of ideas," is from Robert Berkhofer, "Clio and the Culture Concept in Historiography," in *The Idea of Culture in the Social Sciences,* ed. Louis Schneider and Charles M. Bonjean (Cambridge, UK: Cambridge University Press, 1973), 82.

"is seen to be material," is from Stuart Hall, "Introduction," in *Modernity: An Introduction to Modern Societies* (Malden, MA: Blackwell, 1996), 8.

Chapter 1: American culture in red, white, and black

John Higginson quoted in Roderick Frasier Nash, *Wilderness and the American Mind*, 5th ed. (New Haven, CT: Yale University Press, 2014), 37.

"the first drumbeat" Philip Deloria, *Playing Indian* (New Haven, CT: Yale University Press, 1994), 2.

"Arts of Numbering and Measuring . . ." Samuel Johnson, "Advertisement for King's College," May 31, 1754.

Literacy rates in colonial New England from Kenneth A. Lockridge, *Literacy in Colonial New England: An Enquiry into the Social*

 Context of Literacy in the Early Modern West (New York:
 W. W. Norton, 1974), xx.

William Brown quoted from David Henkin and Rebecca McClennan,
 Becoming America: A History of the 21st Century (New York:
 McGraw-Hill Education, 2015), 180.

Chapter 2: Mass culture and mass politics, 1800–1860

T. D. Rice quoted in LeRoy Ashby, *Amusement for All: A History of
 American Popular Culture since 1830* (Louisville: University Press
 of Kentucky, 2006), 10.

"student of the Negro . . .": quoted in David Roediger, *The Wages of
 Whiteness: Race and the Making of the American Working Class*
 (New York: Verso, 1997), 116.

"Burn the damned den of aristocracy!": quoted in David S. Reynolds,
 Walt Whitman's America: A Cultural Biography (New York:
 Vintage Books, 1995), 165.

"those dull papers . . .": quoted in Alexander Saxton, "Problems of
 Class and Race in the Origins of the Mass Circulation Press,"
 American Quarterly 36 (Summer 1984): 211–212.

Joice Heth quote from P. T. Barnum, *The Life of P.T. Barnum, Written
 by Himself*, repr. (Urbana: University of Illinois Press, 2000), 148.

"Who is to decide . . .": quoted in James W. Cook, *The Arts of Deception*
 (Cambridge, MA: Harvard University Press, 2001), 84; "in what
 business is there not humbug?": P. T. Barnum, *Humbugs of the
 World* (New York: Carleton, 1865), 2.

"lower order of man": quoted in Cook, *The Arts of Deception*, 123.

"overspread the continent . . ." is from John O'Sullivan, "Annexation,"
 United States Magazine and Democratic Review 17.8 (July–August
 1845): 5.

Chapter 3: The age of the city, 1860–1900

"the dean of American sculptors": *New York Times*, May 12, 1910, 9.

"enable men to better resist . . .": Spiro Kostof, *A History of
 Architecture: Settings and Rituals*, 2nd ed. (New York: Oxford
 University Press, 1995), 653.

"are ignorant of a park . . .": Roy Rosenzweig and Elizabeth Blackmar,
 The Park and the People: A History of Central Park (Ithaca, NY:
 Cornell University Press, 1992), 239.

"Miss Nancies . . .": quoted in Lawrence W. Levine, *Highbrow/ Lowbrow: The Emergence of Cultural Hierarchy in America* (Cambridge, MA: Harvard University Press, 1998), 239.

"What is the chief end of man?": Mark Twain, *The Revised Catechism*, 1871.

Pear's Soap advertisement from Library of Congress, Prints and Photographs Online Catalog, http://www.loc.gov/pictures/item/2002715038/.

"unconscious finagling": from Stephen Jay Gould, *The Mismeasure of Man* (New York: W. W. Norton, 1986), 87.

E. L. Godkin quoted in Levine, *Highbrow/Lowbrow*, 160.

"perfect instrument for a society . . .": Levine, *Highbrow/Lowbrow*, 41.

Chapter 4: The new mass culture, 1900–1945

Frederick Law Olmsted quoted in John Kasson, *Amusing the Million: Coney Island at the Turn of the Century* (New York: Hill & Wang, 1978), 23.

"pure and unadulterated man-eaters . . .": quoted in Robert W. Rydell, *All the World's a Fair: Visions of Empire at American International Expositions, 1876–1916* (Chicago: University of Chicago Press, 1984), 34.

"civilized, half-civilized and savage worlds . . .": quoted in Rydell, *All the World's a Fair*, 64.

"as if to shame the Negro . . .": quoted in Colin L. Westerbeck, "Frederick Douglass Chooses His Moment," *Art Institute of Chicago Museum Studies* 24.2 (1999): 144–161.

". . . lofty aerial flights": quoted in Kasson, *Amusing the Million*, 63.

Chapter 5: The suburbanization of American culture

"the kind that crazy movie people built in the crazy Twenties." "I am big, it's the pictures that got small!": *Sunset Boulevard*, Paramount Pictures (1950).

"the most modern baseball temple in the world": *Los Angeles Times*, April 10, 1962.

"the ugly and endless sprawls . . .": quoted in Betty Friedan, *The Feminine Mystique, 50th Anniversary Edition* (New York: W. W. Norton, 1997), 289.

"diversity and messy vitality": Jane Jacobs, *The Death and Life of Great American Cities* (New York: Vintage Books, 1961), 149.

Allen Ginsberg, *Howl and Other Poems* (San Francisco: City Lights Books, 1956).

"It's the kids telling us, instead of us telling them": quoted in LeRoy Ashby, *With Amusement for All*, 336.

Chapter 6: The world wide web of American culture

"number one male chauvinist in the world": quoted in Kathryn Jay, *More Than Just a Game: Sport in American Life since 1945* (New York: Columbia University Press, 2004), 172.

"feelings and needs of women": Judy Chicago, *Womanhouse Catalog Essay*, 1971.

"if viewer can take the heat": quoted in Ashby, *With Amusement for All*, 404.

"Roots Too": Matthew Frye Jacobson, *Roots Too: White Ethnic Revival in Post–Civil Rights America* (Cambridge, MA: Harvard University Press, 2008).

Further reading

General

Ashby, Hal. *With Amusement for All: A History of American Popular Culture since 1830*. Lexington: University Press of Kentucky, 2006.

Cook, James W., Lawrence B. Glickman, and Michael O'Malley. *The Cultural Turn in U.S. History: Past, Present and Future*. Chicago: University of Chicago Press, 2008.

Haltunnen, Karen, ed. *Blackwell Companion to American Cultural History*. Malden, MA: Blackwell, 2008.

Colonial period and nineteenth century

Barth, Gunther. *City People: The Rise of Modern City Culture in Nineteenth-Century America*. New York: Oxford University Press, 1980.

Cohen, Patricia Cline. *The Murder of Helen Jewett: The Life and Death of a Prostitute in Nineteenth-Century New York*. New York: Knopf, 2010.

Cook, James W. *The Arts of Deception: Playing with Fraud in the Age of Barnum*. Cambridge, MA: Harvard University Press, 2001.

Deloria, Philip. *Playing Indian*. New Haven, CT: Yale University Press, 1998.

Haltunnen, Karen. *Confidence Men and Painted Women: A Study of Middle-Class Culture in America, 1830–1870*. New Haven, CT: Yale University Press, 1982.

Harris, Neil. *Humbug: The Art of P.T. Barnum*. Chicago: University of Chicago Press, 1973.

Henkin, David. *City Reading: Written Words and Public Spaces in Antebellum New York*. New York: Columbia University Press, 1998.

Horsman, Reginald. *Race and Manifest Destiny: The Origins of American Racial Anglo-Saxonism*. Cambridge, MA: Harvard University Press, 1981.

Kamensky, Jane. *Governing the Tongue: The Politics of Speech in Early New England*. New York: Oxford University Press, 1991.

Kasson, John. *Rudeness and Civility: Manners in 19th Century Urban America*. New York: Hill and Wang, 1990.

Levine, Lawrence. *Black Culture and Black Consciousness: Afro-American Folk Thought from Slavery to Freedom*. New York: Oxford University Press, 1977.

Levine, Lawrence. *Highbrow/Lowbrow: The Emergence of Cultural Hierarchy in America*. Cambridge, MA: Harvard University Press, 1988.

Lott, Eric. *Love and Theft: Blackface Minstrelsy and the American Working Class*. New York: Oxford University Press, 1993.

Nash, Roderick Frasier. *Wilderness and the American Mind*. 5th ed. New Haven, CT: Yale University Press, 2014.

Pestana, Carla. *Religion and the Making of the British Atlantic World*. Philadelphia: University of Pennsylvania Press, 2009.

Rosenzweig, Roy, and Elizabeth Blackmar. *The Park and the People: A History of Central Park*. Ithaca, NY: Cornell University Press, 1992.

Rydell, Robert. *All the World's a Fair: Visions of Empire at American International Expositions, 1876–1916*. Chicago: University of Chicago Press, 1984.

Saxton, Alexander. *The Rise and Fall of the White Republic: Class Politics and Mass Culture in Nineteenth Century America*. London: Verso, 1990.

Warren, Louis. *Buffalo Bill's America: William Cody and the Wild West Show*. New York: Knopf, 2005.

Twentieth century

Avila, Eric. *Popular Culture in the Age of White Flight: Fear and Fantasy in Suburban Los Angeles*. Berkeley: University of California Press, 2004.

Cripps, Thomas. *Slow Fade to Black: The Negro in American Film, 1900–1942*. New York: Oxford University Press, 1993.

Denning, Michael. *The Cultural Front: The Laboring of American Culture in the Twentieth Century*. New York: Verso, 1997.

Echols, Alice. *Hot Stuff: Disco and the Remaking of American Culture*. New York: W. W. Norton, 2010.

Glenn, Susan. *Female Spectacle: The Theatrical Roots of Modern Feminism*. Cambridge, MA: Harvard University Press, 2000.

Gray, Herman. *Watching Race: Television and the Struggle for Blackness*. Minneapolis: University of Minnesota Press, 2004.

Jacobson, Matthew Frye. *Roots Too: White Ethnic Revival in Post–Civil Rights America*. Cambridge, MA: Harvard University Press, 2006.

Kasson, John. *Amusing the Million: Coney Island at the Turn of the Century*. New York: Hill & Wang, 1978.

Kelley, Robin D. G. *Race Rebels: Culture, Politics and the Black Working Class*. New York: Free Press, 1994.

May, Elaine Tyler. *Homeward Bound: American Families in the Cold War Era*. New York: Basic Books, 1998.

May, Lary. *Screening Out the Past: The Birth of Mass Culture and the Motion Picture Industry*. Chicago: University of Chicago Press, 1980.

May, Lary. *The Big Tomorrow: Hollywood and the Politics of the American Way*. Chicago: University of Chicago Press, 2000.

Nasaw, David. *Going Out: The Rise and Fall of Public Amusements*. Cambridge, MA: Harvard University Press, 1993.

Peiss, Kathy. *Cheap Amusements: Working Women and Leisure in Turn of the Century New York*. Philadelphia: Temple University Press, 1986.

Rose, Tricia. *Black Noise: Rap Music and Black Culture in Contemporary America*. Middletown, CT: Wesleyan University Press, 1994.

Ross, Steven J. *Working-Class Hollywood: Silent Film and the Shaping of Class in America*. Princeton, NJ: Princeton University Press, 1998.

Ryan, Michael, and Douglas Kellner. *Camera Politica: The Politics and Ideology of Contemporary Hollywood Film*. Bloomington: Indiana University Press, 1988.

Sandweiss, Martha A. *Print the Legend: Photography and the American West*. New Haven, CT: Yale University Press, 2002.

Sklar, Robert. *Movie-Made America: A Cultural History of American Movies*. New York: Random House, 1975.

Smith, Suzanne. *Dancing in the Street: Motown and the Cultural Politics of Detroit*. Cambridge, MA: Harvard University Press, 1999.

Spigel, Lynn. *Make Room for TV: Television and the Family Ideal in Postwar America*. Chicago: University of Chicago Press, 1992.

Index

B

C